Acrylic
LANDSCAPE
Painting
Techniques

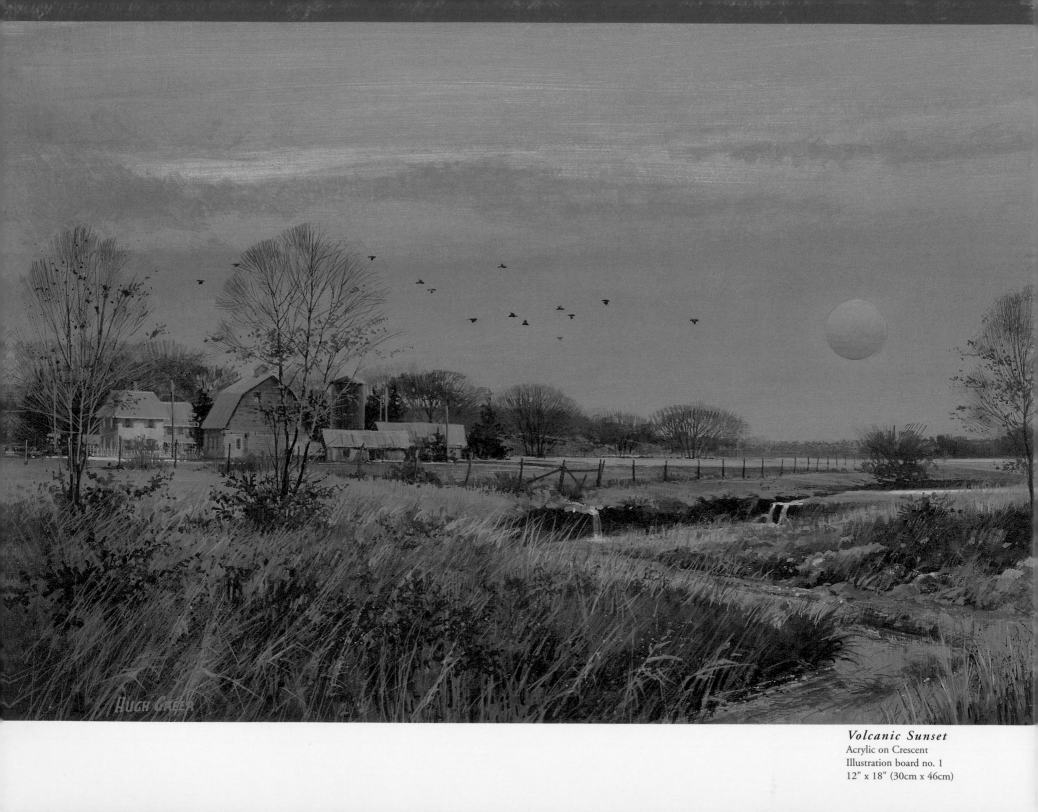

Volcanic Sunset
Acrylic on Crescent
Illustration board no. 1
12" x 18" (30cm x 46cm)

Acrylic
LANDSCAPE
Painting
Techniques

NORTH LIGHT BOOKS
www.artistsnetwork.com

Acrylic Landscape Painting Techniques. Copyright © 2002 by Hugh Greer. Manufactured in China. All rights reserved. No part of this book may be reproduced in any form or by any electronic or mechanical means including information storage and retrieval systems without permission in writing from the publisher, except by a reviewer who may quote brief passages in a review. Published by North Light Books, an imprint of F & W Publications, Inc., 1507 Dana Avenue, Cincinnati, Ohio 45207. 1-(800)-289-0963. First Edition.

06 05 04 03 02 5 4 3 2 1

Library of Congress Cataloging in Publication Data
Greer, Hugh.
 Acrylic landscape painting techniques / by Hugh Greer. — 1st ed.
 p. cm
 Includes index.
 ISBN 1-58180-063-0 (hc. : alk. paper)
 1. Landscape painting— Technique. 2. Acrylic painting—Technique. I. Title.

ND1342 .G74 2001
751.4'26—dc21
 2001030972
 CIP

Edited by Marilyn Daiker & James A. Markle
Designed by Lisa Buchanan
Production art by Donna Cozatchy
Production coordinated by Kristen Heller

Dedication

This book is dedicated to my grandchildren

(and yours if you have them): Collin and

Anna Wierda and Baylee Ann Bristow.

Their future is in our hands until the day

our future is in their hands!

METRIC CONVERSION CHART		
To convert	**to**	**multiply by**
Inches	Centimeters	2.54
Centimeters	Inches	0.4
Feet	Centimeters	30.5
Centimeters	Feet	0.03
Yards	Meters	0.9
Meters	Yards	1.1
Sq. Inches	Sq. Centimeters	6.45
Sq. Centimeters	Sq. Inches	0.16
Sq. Feet	Sq. Meters	0.09
Sq. Meters	Sq. Feet	10.8
Sq. Yards	Sq. Meters	0.8
Sq. Meters	Sq. Yards	1.2
Pounds	Kilograms	0.45
Kilograms	Pounds	2.2
Ounces	Grams	28.4
Grams	Ounces	0.04

Golden®, Golden Fluid Acrylics©, Golden Heavy Body Artist Acrylics©, Golden Polymer Varnish with UVLS© and Golden Soft Gel© are registered trademarks of the Golden Company.

Ampersand®, Hardbord© and Gessobord© are registered trademarks of Ampersand Art Supply.

Author

The Red Hot Take Off

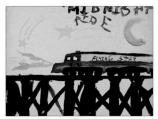

Midnight Ride

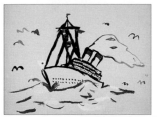

Out at Sea

Even as a seven-year-old, Hugh Greer painted what captured his imagination: the countdown of the Spit Fire in *The Red Hot Take Off*, the Flying Star crossing a train trestle in *Midnight Ride*, and a cruise ship at sunrise in *Out at Sea*.

Those early landscapes and seascapes that explored the mystery of the heavens, the adventure of the rails and the depths of the ocean have proved foretelling. Greer, now an acclaimed landscape and still-life artist, is still fueled by curiosity and imagination.

Perhaps more grounded now, his paintings explore light, color and texture: golden forsythia in snow; a rich red summer sumac lining a hillside; shimmering aspens in fall and a car speeding down a dirt road to beat the oncoming storm. Greer finds a joy, a truth and unadulterated poetry in snowy back-road villages in northern New Mexico and dirt lanes in rural Kansas. His 1997 book *Hugh Greer, Missouri to New Mexico* explored those paths less taken, with paintings created along the journey and accompanying poetry by Cathy Bolon Stephenson.

With a formal education in industrial design and architecture, Greer's fine art technique is confident, precise and passionate. He's a baseball enthusiast and former competitive fisherman who shares a love of the great outdoors with his wife Terry. They live on five acres of rural property outside of Wichita with a black lab named Ajax and a kitty named Smokey. Greer has a studio on the property and a second studio eighty miles away in the Kansas Ozarks, complete with spring-fed pond.

Greer is represented by four galleries: The Wichita Gallery of Fine Art, Wichita, Kansas; The Courtyard Gallery, Lindsborg, Kansas; Wadle Galleries, Santa Fe, New Mexico; and The American Legacy Gallery, Kansas City, Missouri.

Linda Shockley

TABLE OF Contents

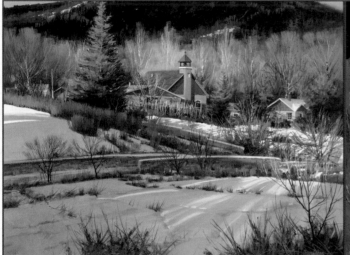
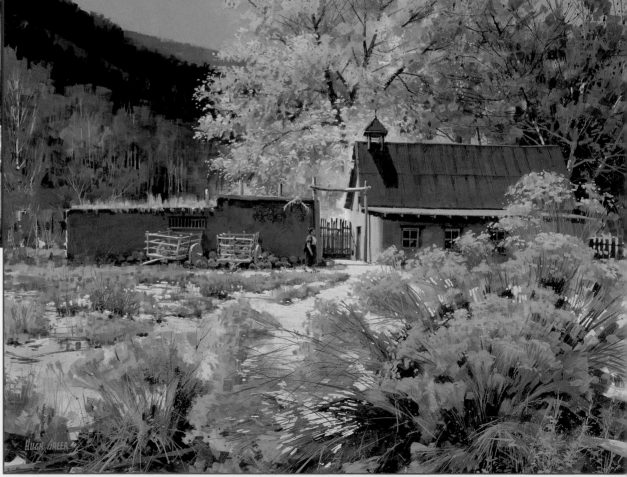

INTRODUCTION

Choosing Your Way to Create

"What are you doing now?" a classmate inquired when I recently attended my fortieth high school reunion. When I replied, "I'm an artist," he asked in return, "Yes, but what do you do during the day?"

It's a funny story but also an exasperating one. You see, I paint because I have a passion for it. I paint because I have a talent for it. And I paint because my financial life depends on it.

Painting is hard work although joyous, gratifying and challenging. This book won't lessen the work; you simply can't avoid it. But it's my hope that it will provide many invigorating ideas and effective exercises you can use to stimulate your thought processes, advance your personal style and enhance your technique. My goal is to provide the tools and exercises that will inspire you to become a more prolific and passionate painter, whether you are a Sunday painter or a professional painter.

Discovery, Discipline and Dedication

I seem to spend a lot of time listening to artists debate the merits and disadvantages of the two approaches to the professional art world: self-taught artists vs. schooled artists. I believe there are great artists in each camp, and suspect that regardless of the approach—self-taught or schooled—the key to success is talent and hard work, resulting in a signature style.

On my own path, I received a degree in Industrial Design from Kansas University. The discipline of being an architectural artist for thirty-seven years helped form my own style. Many of the tools I use every day are the same ones I used during my architectural days. While some of these tools are quite old (perhaps as old as I am, teases my wife Terry) they can still be found and used.

You don't want to paint like me, and I don't want you to paint like me. I hope my tried-and-true tips will promote and encourage the development of your own signature style. That personal style is one critical measure of how your work will be judged and valued. Just as importantly, your comfort level with your personal style is a crucial measure of how you will evaluate your personal and professional success.

In addition to specific how-to tips and comprehensive exercises, this book provides a buyer's guide for materials. Explore it and see what works best for you. This guide may be particularly helpful if your local art supply store has limited or only traditional offerings. Use the source that works for you.

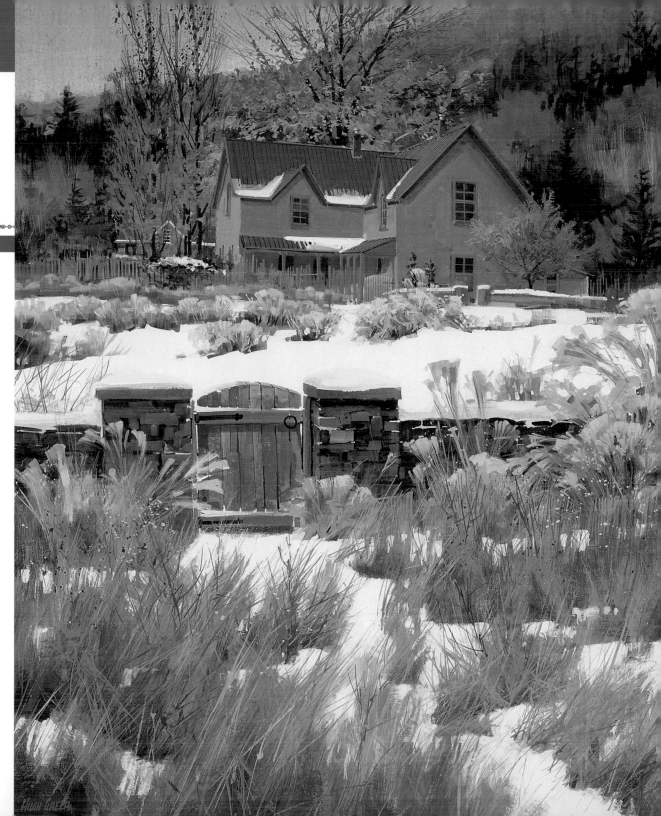

The Blue Gate
Acrylic on Gessoed Hardbord
20" x 16" (51cm x 41cm)

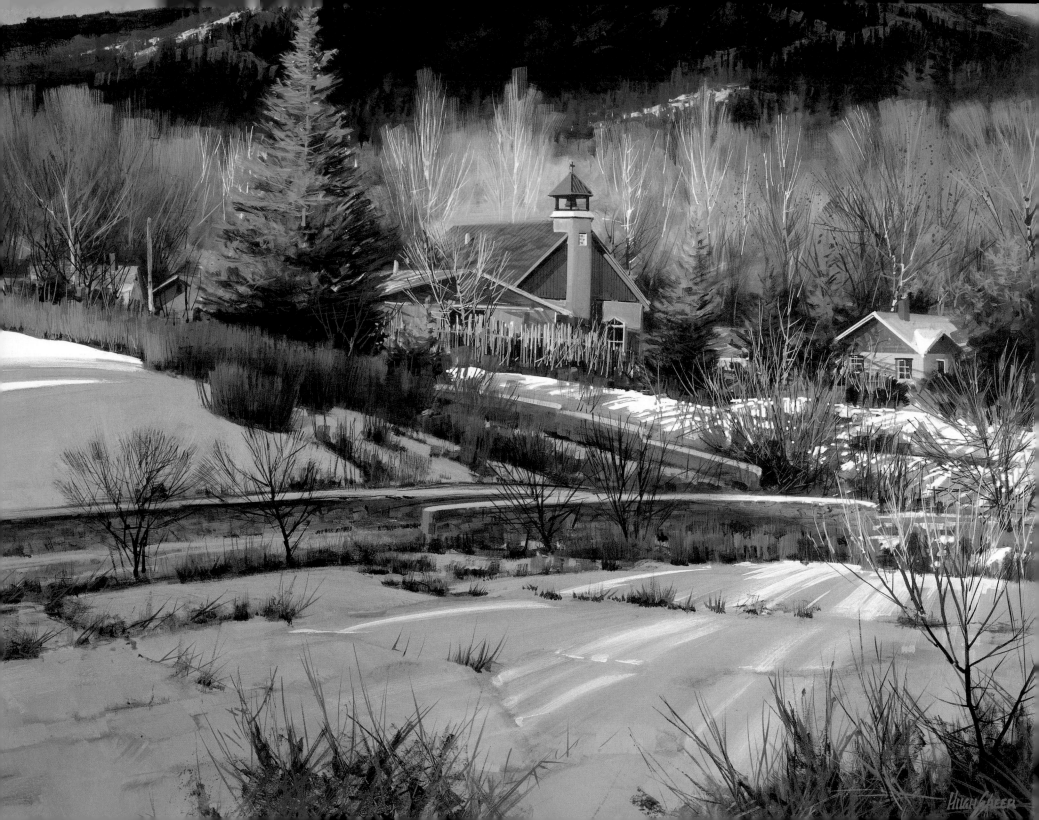

Materials

For the past forty years I've worked as an architectural illustrator; this has given me the opportunity to learn about some unusual tools, some of which I'll show you in this book. A quick look at the buyer's guide at the end of this book will help you track down some of the tools and materials that you may find helpful.

Shadow Dance
Acrylic on Crescent Illustration board no. 1
18" x 24" (46cm x 61cm)

The Window

One extremely useful tool is a window I developed to facilitate the sketching process, though it is by no means a substitute for good drawing skills. This technique enables me to register a proportionately accurate sketch, because there is no distortion as is often the case with photographs. As I travel, I make a quick sketch of a scene on a transparent window and take a few photographs. I'll use the sketch when I get back home to lay out a drawing. The photographs refresh my memory and highlight particular details that inspired me to choose the scene in the first place.

Use a good black dense pen for sketching. There are several brands that will write on plastic and are available at your local art supply store. Some of these can even be erased off the plastic with a little bit of rubbing alcohol.

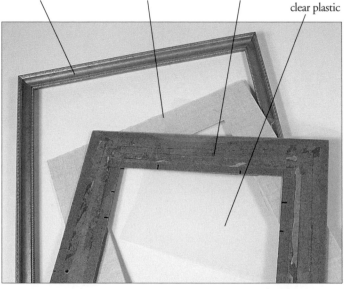

Old picture frame Heavy cardboard mat Masonite board Piece of clear plastic

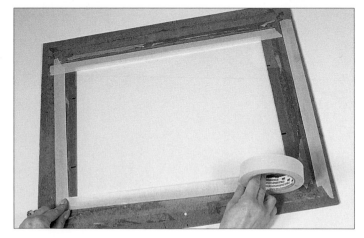

Choose or Make a Frame

A simple window can be made from an old frame, a heavy cardboard mat or a piece of Masonite. This frame was made from a ⅛" (3mm) piece of Masonite. The opening of the window is 12" x 16" (30cm x 41cm) and the Masonite is slightly larger than the window. Cut an opening for the window using a craft knife. Score both sides of the board until the cutout can be released. Cut a piece of clear plastic slightly larger than the opening you've made.

Tape the Clear Plastic to the Frame

Tape the plastic over the window. You can also use a single piece of Plexiglas if you prefer.

MATERIALS LIST

Clear plastic film or Plexiglas
Craft knife
Masonite or heavy mat board
Straightedge ruler
Tape

PLEXIGLAS

A piece of Plexiglas would also make a great window. It is rigid enough on its own so you don't need to use a frame. The advantage of using clear plastic film on a frame is that you can roll up the plastic and store it until you get back home.

Using a Window

MATERIALS LIST

Ballpoint pen
Black pen that writes on
 plastic
Gessobord 9" x 12" (22cm
 x 30cm)
Objects for still-life compo-
 sition
Pad of paper
Pencils
Saral paper (or pastel)
Tripod (or other support
 to hold window in
 position)
Window

Now that you have made a window, try it out with this practice exercise. Set up a simple still life—a few boxes, a ball, whatever is handy—using simple shapes for your composition.

Assemble Your Sketching Tools

For sketching, you will need the following items: your window, a pad of paper, pencils, a black pen that writes on plastic, tracing paper, Saral paper or a pastel and tape.

STEP *1* | *Assemble a Still Life*

Gather some objects that will create an interesting composition.

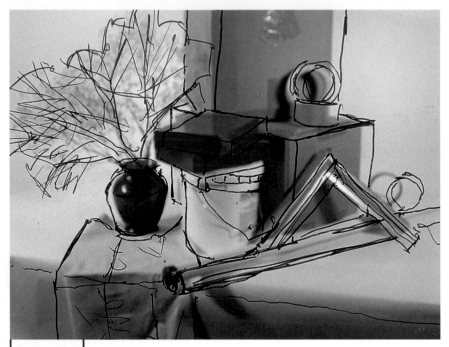

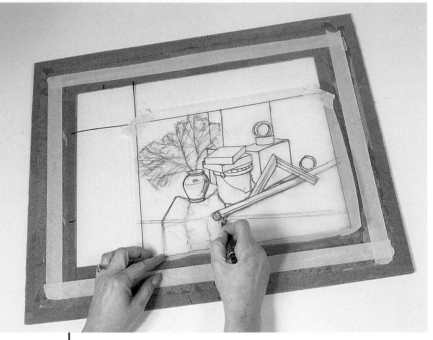

STEP 2 | *Arrange Your Window*

Mark off a 9" x 12" (23cm x 30cm) section on the window (I usually work with these dimensions initially, and enlarge the sketch if it is promising). Hold the window out at arm's length and look at your still life through it. Adjust your position for the right distance from the scene. Use a tripod or anything sturdy to help stabilize your window in the correct position as you sketch. Put a spot or dot on the clear plastic that lines up with an object in the scene. Check the alignment constantly because your head will move a little bit and you want to keep everything in the correct position. This sketch should take less than five minutes to complete.

STEP 3 | *Lay Tracing Paper Over Your Drawing*

After drawing the big shapes on the plastic window, lay a piece of tracing paper over the drawing. Use a pencil to clean up your sketch. Add details where necessary.

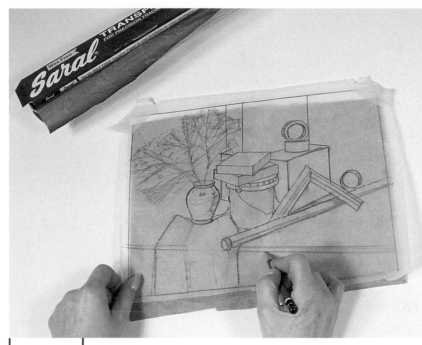

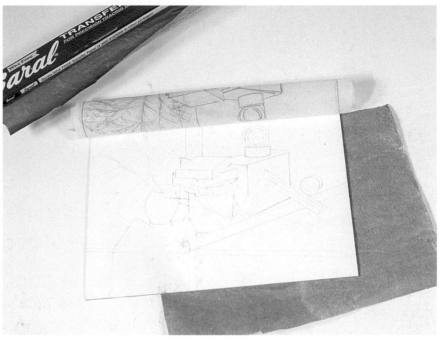

STEP 4 | Transfer Your Sketch

You should now have a very suitable and proportionately accurate drawing to transfer onto Gessobord or other support. Cut a piece of Saral paper large enough to accommodate your sketch. Put the Saral paper, graphite side down, onto the Gessobord. Place your sketch on top of the Saral paper. Use a ballpoint pen to trace over the sketch to transfer it to the Gessobord.

Final

Pull back the tracing paper and lift off the Saral paper to inspect the transferred sketch. You can begin laying in color.

TRANSFERRING A SKETCH

You can use Saral paper to make the transfer, or you can fully coat the back of your sketch with a pastel and use that to make the transfer. If you are making a transfer to a hard surface like gessoed Masonite, use a ballpoint pen to trace over your sketch. If you are making the transfer to a piece of paper, consider using a pencil instead because pencil doesn't leave indentations like a ballpoint pen.

Proportional Dividers

Proportional dividers can be used to enlarge or reduce an already existing sketch or photograph. You can set the dividers at ratios from a 1:1–10:1 ratio. The knob allows you to choose the appropriate setting. Even though this is a very old tool, it can still be purchased today.

Measure and Reduce the Subject

Set up a still life and practice using dividers. The dividers are set at a 2:1 ratio, so as I sketch the still life, I'll be reducing it by one-half. For each line, take a measurement with the wider side of the dividers.

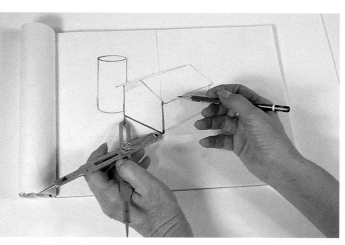

Draw the Subject

Turn the dividers to the narrow side to draw a proportionately accurate but reduced line on your sketch.

Enlarge the Subject

The small sketch is on a 9" x 12" (23cm x 30cm) sheet of tracing paper, and I'm transferring the sketch to fit on an 18" x 24" (46cm x 61cm) sheet of tracing paper. The proportional dividers are set at a 1:2 ratio, so as I sketch, I will be enlarging the sketch to twice its original size. The red grid is helpful in positioning and is also at a 1:2 ratio.

Painting Materials

Besides the sketching materials already discussed, you may need to buy several items for painting. Don't get discouraged; all you need to get started are these basic supplies:

- Acrylic paintbrushes
- Paint (discussed in chapter two)
- Palette or something to mix your colors in
- Paper towels
- Support or something to paint on
- Water bucket

The following supplies can be added when you are ready to try some or all of the demonstrations described throughout the book. Look for detailed descriptions of some of these materials:

- Bridge
- Craft knife
- Flex curves
- Hair dryer
- Lift-out tool
- Liquid masking fluid
- Palette knife
- Ruling pen
- Spray bottles

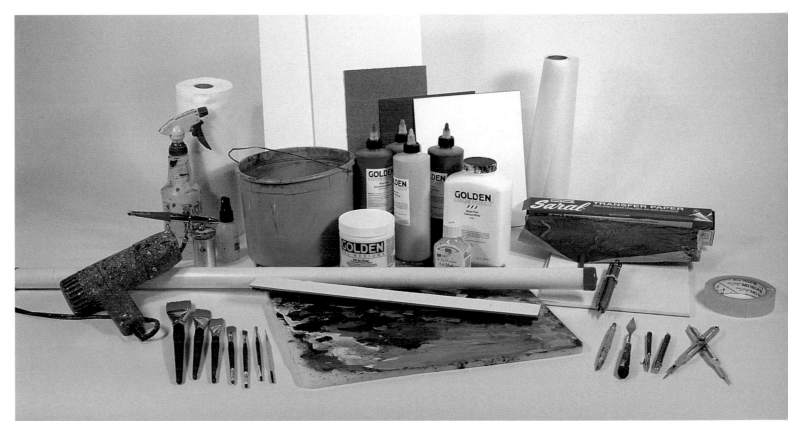

Supplies

Here are some of the basic supplies you need to get started.

PALETTE

Just about anything can be used as a palette as long as it is nonabsorbent. I use a cutting board made from a rubberized plastic. You can pick one up at a local discount store. A cutting board palette is preferable when mixing thin washes, because the washes do not bead up into pools of color. A porcelain pan also makes a pretty good palette. You can buy disposable palettes, which are great for painting outdoors.

Supports

I like to paint on acrylic gessoed Masonite, especially outdoors. It is a hard, dense surface that is relatively slow drying and I can get a high degree of detail from the smooth surface. A paper surface is more porous and gives softer edges. It lends itself to softer backgrounds like fog and mist on a rainy day. Paper retains its absorbency, even after several coats of thin washes have been applied. Consider the subject matter when determining which surface to use.

Paper or Rag Surface

Use a one-hundred percent rag surface paper like Crescent Illustration board no. 1. There is only minimal warping when washes are applied, so it is a good surface to use when using acrylics as watercolors. The paper can be cut with a craft knife. Don't be afraid to experiment with paper. Try sealing the surface with one coat of Golden Soft Gel, gloss or matte finish, and see how your paint reacts. Add more coats, experimenting with each. The surface becomes less absorbent with each coat.

Untempered Masonite

Purchase untempered Masonite from your local lumberyard in ⅛" (3mm) or ¼" (6mm) thick pieces. It can be cut with a craft knife or saw. When cutting with a craft knife, both sides of the Masonite have to be scored on an identical line, and then it can be snapped apart. The edges will need to be lightly sanded. The composition of this product is inconsistent, so to remedy the problem, apply one coat of Golden Soft Gel. When dry, apply at least two coats of gesso. When the gesso is dry, the support is ready to be painted.

Gessobord

These smooth boards can be purchased at most local art supply stores, and they are ready to accept paint without treating. Gessobord is a good surface to use when you know you'll be using the lift-out tool. The smooth, nonporous surface makes for a clean liftoff, and is great for detail work.

Hardbord

This product looks and feels like tempered Masonite, but it does not contain oil like Masonite does. You can buy it in ⅛" (3mm) or ¼" (6mm) thicknesses. This is the surface I use the most. You may have to contact Ampersand directly for the location of the nearest dealer.

Brushes

I prefer to use Winsor & Newton series 580 brushes. These one-stroke brushes come in sizes from 1½-inch (38mm) to ⅛-inch (3mm) wide. Always start off with the largest brush you can handle and work your way down to the smaller brushes as you work on finer detail. The advantage of using a one-stroke brush is that it holds more paint. Flats also work, but I prefer the one-stroke.

Smaller detail work can be done with the ⅛-inch (3mm) one-stroke in the 580 series. You'll be surprised by the amount of detail you can get with these brushes by just using the corner. Or you can use a no. 0, 1, 2 or 3 script brush. You might want to keep several of the smaller brushes in your inventory as they have a tendency to wear out. They are synthetic, and you can expect them to be in top shape for three to five paintings. When they become frizzed or fuzzed, they are no longer useful and you'll want to replace them. The good news is that they are reasonably priced.

One-Stroke Brush

This ¾-inch (19mm) wide, one-stroke brush can deliver a variety of line work. Use the corner edge for fine detail work. Use the broad side when covering wide, heavier areas.

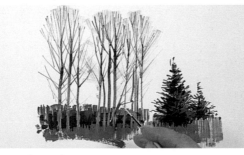

Brush Technique

The ⅛-inch (3mm) one-stroke brush was used to create the trunk of the tree. The finer limbs in the top of the tree were done with a splayed ¼-inch (6mm) or ⅛-inch (3mm) one-stroke brush to achieve almost a dry-brush effect. I used a thinner mixture of paint and literally fanned out the top of the brush and lightly stroked in the fine limbs. Fine line work in the tree limbs was done with a variety of script brushes.

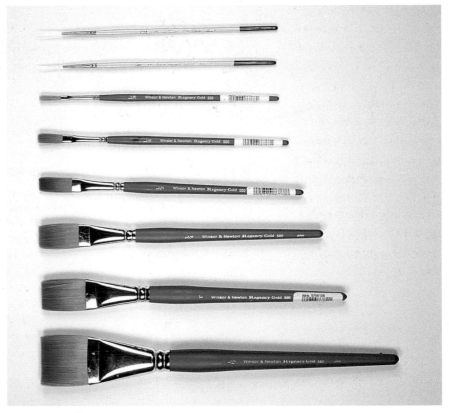

Basic Brushes

To get started, you should buy script brushes nos. 1 and 2, and ⅛-inch (3mm), ¼-inch (6mm), ½-inch (12mm), ¾-inch (19mm), 1-inch (25mm) and 1½-inch (38mm) wide one-strokes.

The Bridge

You can buy a bridge tool or make one yourself. The bridge can be made out of practically anything: plastic, cardboard, wood or even a yardstick. The bridge enables you to keep your hands off your painting. Not only will it keep you out of the wet paint, it will also serve as a stabilizer and a straightedge. If you attach a piece of cut mat board to the bridge, it will give you a place to shape your brush before you put down a stroke. When the edge builds up with too much paint, replace it. When it's time to replace the old strip, cut a strip of mat board and adhere it to the bridge with a piece of double-faced tape.

Using a Bridge
Your brush can lay up against the bridge and enable you to paint nice, clean straight lines.

Flexible Curves and the Bridge
A flexible curve placed on top of the bridge will produce clean, smooth-flowing lines. Practice with a ¼-inch (6mm) brush. If you want to put in telephone or fence lines, use a finer script brush (no. 1 or 2) with a flexible curve to make thin, sweeping lines.

Modifying Your Bridge
A cardboard strip on the top side of the bridge can be used to shape your brush while painting. When paint accumulates on the cardboard you can simply replace the strip.

Sprays

Use a coarse-spray bottle to put down large drops of water. These large drops help create special effects for trees and clouds. Putting thinned-down pigment into it produces a lacy effect. You can pick up a coarse-spray bottle at a hardware or discount store.

The medium-spray bottle is probably the one I use most often. It is used only to keep the surface damp, which will give you more time to blend edges. Both coarse and medium sprays will disturb the surface and interrupt the film of paint you have on your board.

The airbrush creates the finest mist I've found. The only liquid I use in the airbrush is pure, clear water. I've never put acrylic paint in this utensil because it is a headache to keep clean. The airbrush will spray a light film of moisture onto your board and will not disturb the surface paint unless you saturate it. Use this spray to help keep the surface damp a little longer. Of the three sprays, this is probably one spray an artist can do without, but is handy in keeping paint wet long enough to blend it.

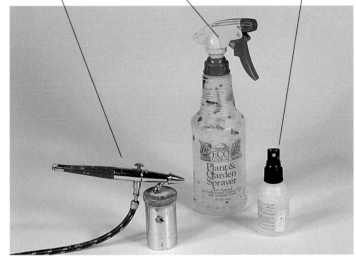

Airbrush (for fine mists) Coarse-Spray bottle Medium-Spray bottle

Three Options for Sprays

There are three types of sprays you can choose from: coarse, medium and fine. Each one produces a different effect.

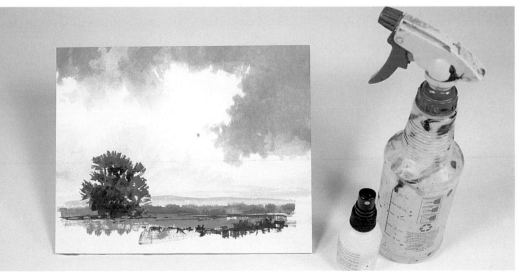

Using a Coarse Spray

Spray the sky area and let the beads roll up. While still wet, begin painting on the beaded surface. The pigment will jump from bead to bead, giving a softer edge and a lacy look. Use your hair dryer to dry the surface between steps. Lay down another spray and paint in the background hill and trees followed by the larger tree in the foreground. Be sure to dry the surface with the hair dryer before you spray again, or the paint will run all over the place.

Lift-Out Tool

MATERIALS LIST

ACRYLIC PAINTS
Anthraquinone Blue
Cerulean Blue
Diarylide Yellow
Quinacridone Magenta
Titanium White

BRUSHES
One-stroke brushes: ⅛-inch
(3mm), ¼-inch (6mm)
Script brushes: nos. 1
and 2

ADDITIONAL SUPPLIES
Lift-out tool
Palette
Palette knife
Paper towels
Support
Water

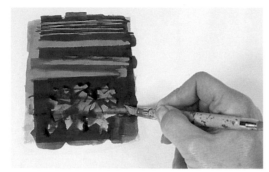

Practice Using a Lift-Out Tool

Lay down a coat of paint and let it dry. Layer another color over this and while this new color is still wet, lift out portions of the paint down to the base color.

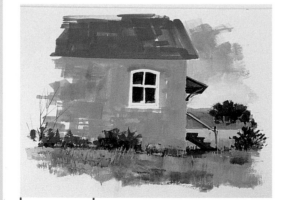

STEP 1 Lay Down Color

To illustrate stone, you can put down color that would represent the stone in a random pattern. Don't worry about getting it on smoothly. Actually, some brushstrokes would be very beneficial. This will be your base color.

KEEP YOUR LIFT-OUT TOOL CLEAN

When you use the lift-out tool it is very important to have a wad of paper towels handy so you can keep the tip of the tool clean. Clean off the tip of the tool every few strokes.

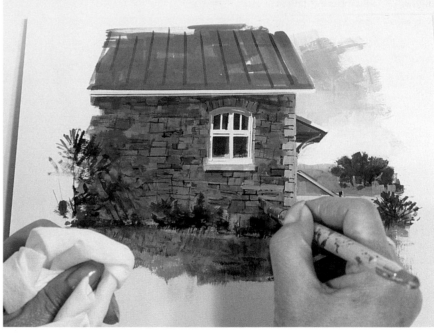

Final

Let the base color dry. Put on a darker, shaded color, and while it is still wet, start lifting out individual stones. To define the joints in between the stones, use a no. 1 or 2 script brush. It is not necessary to show every single joint with the fine script brush because that makes the art monotonous.

Ruling Pen

The ruling pen is also a traditional tool with many wonderful applications. You fill the ruling pen with acrylic paint and it delivers a fine line that is excellent for detail work. It can still be found in some art/drafting supply stores and catalogs, but with the advent of computers, some fine art tools are becoming harder to locate and ruling pens are becoming obsolete. When you find a ruling pen, be sure to take good care of it. As a matter of fact, buy two of them; it's always nice to have a spare.

The Ruling Pen

Originally designed in the 1900s to hold ink for ink drawings, this pen might be found in your grandfather's set of drafting tools or it can still be purchased today at some art/drafting supply stores. Simply fill the tip with the paint color you need. Rinse well before changing colors.

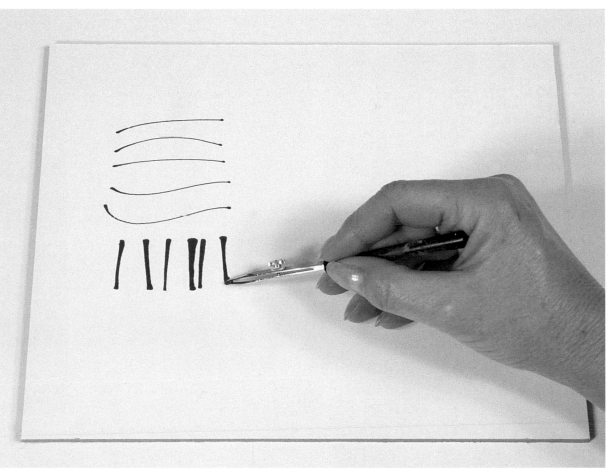

Using the Ruling Pen

When using the point or tip of the ruling pen, you can adjust the width of the line for fine or wide strokes. To get the widest line, lay the pen on its side and drag it. There is little control in this particular method, so you might prefer a brush when you need a wider line.

Lift-Out Tool and Ruling Pen

This demonstration is painted on Gessobord. This support has a very smooth surface, which is helpful when using a lift-out tool in your painting.

STEP *1* | *Paint a Wash*

Paint a wash of Quinacridone Magenta combined with Diarylide Yellow and a touch of Titanium White on a piece of Gessobord. This will serve as the underpainting. When this is dry, you can sketch directly on it.

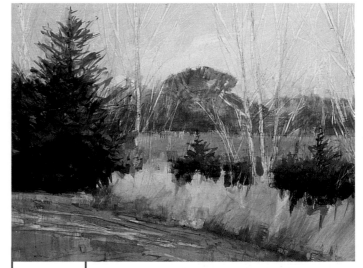

STEP *2* | *Lift Out the Tree Trunks*

Mix a color of reddish brown using Diarylide Yellow, Quinacridone Magenta and Anthraquinone Blue. Lean a little bit heavier on the blue side and make a rich, warm brown tone to paint the background trees. While the color is still wet, lift out the tree trunks, letting the color underneath show through. Mix a pale blue sky color using Cerulean Blue and Titanium White. Paint the sky above the trees, and while that is still wet, lift out the tree limbs and trunks.

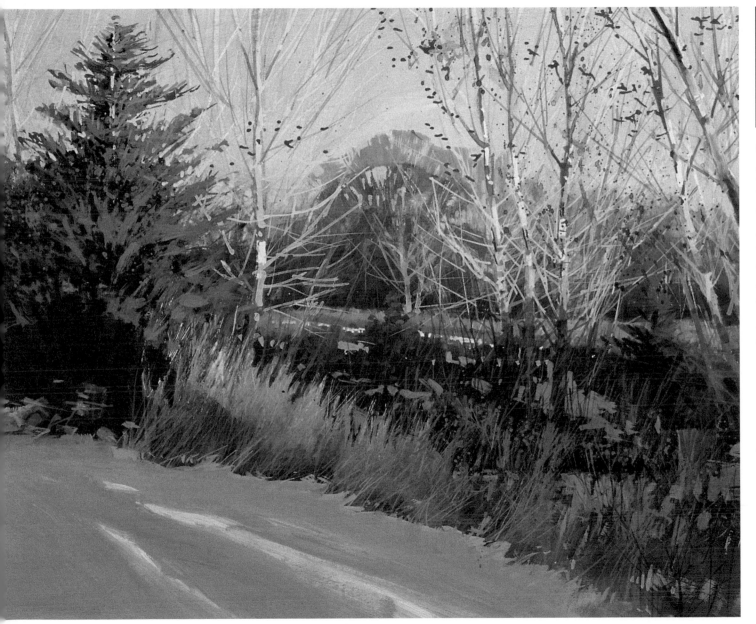

The lift-out tool works better on a primed and coated board such as Gessobord as opposed to a paper surface because paper absorbs the pigment and dries too quickly.

Final

Paint the foreground snow with a thin wash of Titanium White and let it dry. Over this wash, paint a medium blue mixture of Anthraquinone Blue, Titanium White and Cerulean Blue. While this is wet, use the lift-out tool to expose the sunlit snow. Now mix a touch of Titanium White with Diarylide Yellow and brush it into the ruling pen. This will give you an intense bead of color for a highlight on the snow. The leaves in the bushes and dark tree limbs are also put in with the ruling pen.

5 O'clock Shadows
Acrylic on Gessobord
8" x 10" (20cm x 25cm)

A Place to Paint

Painting Indoors

If you are just beginning to paint you do not need an elaborate set-up to get you started. Any kind of table will do. The table I use is not large, but very convenient. It folds up and travels easily. The tabletop adjusts to any angle from vertical to flat. The chair seat and back are adjustable and the seat has a built-in air cushion.

The side table or taboret is the heart of the operation, and is on wheels. I can store all my supplies inside this table. I pull out one of the drawers and place my palette on it.

Painting Outdoors

Because I prefer to work on a flat surface, I set up my modified easel to suit my needs. Anything you are comfortable with and can carry around will work. My outdoor easel has a folding chair, an inflatable water bucket, a side tray to hold paints and a shallow water pan to lay my brushes in to keep them from drying out. When you are painting outdoors, you are usually in the wind, sun or both, and the brushes tend to dry out faster than when you're working in controlled conditions.

I've collected two-ounce (57g) and four-ounce (114g) glass jars over the years. I put my base palette in the small ones (see chapter two). The larger jar is for white because I use more of that than any other color. Plastic jars will work, but over time the acrylic paint fuses to them and it's difficult to unscrew the tops. The jars of paint, brushes and all the equipment I need to paint outdoors fit inside the easel box. Everything folds up neatly and can be carried around. I can't carry it on an eight-mile hike, but it works great for short distances.

When painting outdoors, your whole thought process has to speed up because you have to paint faster. The early morning or late evening light changes quickly as you try to capture the essence of the moment. I've been a studio painter for many years, and I want to encourage you to paint outdoors, even if it's in your own yard. It will stir your imagination! You will see colors you didn't know were there. The colors are more intense than from any photo you might have, and certainly more brilliant than your memory can recall. You'll be able to mix colors that will surprise you and make you wonder where they came from. This ability is a result of painting on location and can't be duplicated in the studio.

Another advantage to painting outdoors is learning to paint quickly. This will require you to eliminate unnecessary elements from your painting.

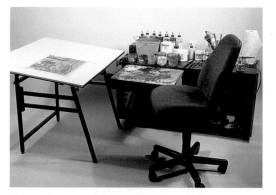

Painting in the Studio

To paint indoors you need your supplies: a table or easel, a comfortable chair and a good taboret or cart to conveniently hold all of your equipment.

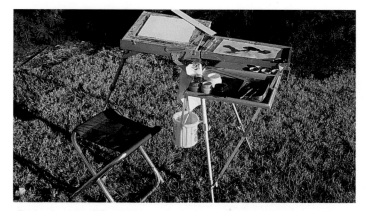

Painting in Nature

When painting outdoors you need to be organized and travel light. You will need a portable easel and collapsible chair as well as your basic tools. Everything should fit easily into your easel box.

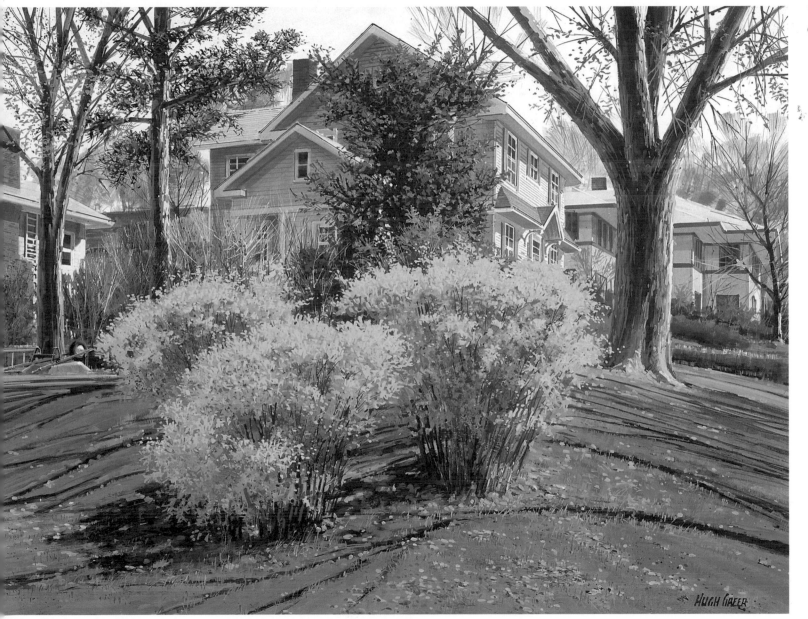

What the Right Tools Can Do for You

I used many of the tools covered in this chapter to paint *Flirting With Spring*. A spray bottle was used to break up the leaf splatters in the winter trees and forsythia bush. A lift-out tool helped create the shadows around the forsythia bush and the dark green trees behind the bush. Some of the light branches were scratched out with a craft knife. I used a ruling pen on the brick joints, gutter line, tree limbs and on the lightest, brightest leaves in the forsythia bush.

Flirting With Spring
Acrylic on Crescent Illustration board no. 1
18" x 24" (46cm x 61cm)

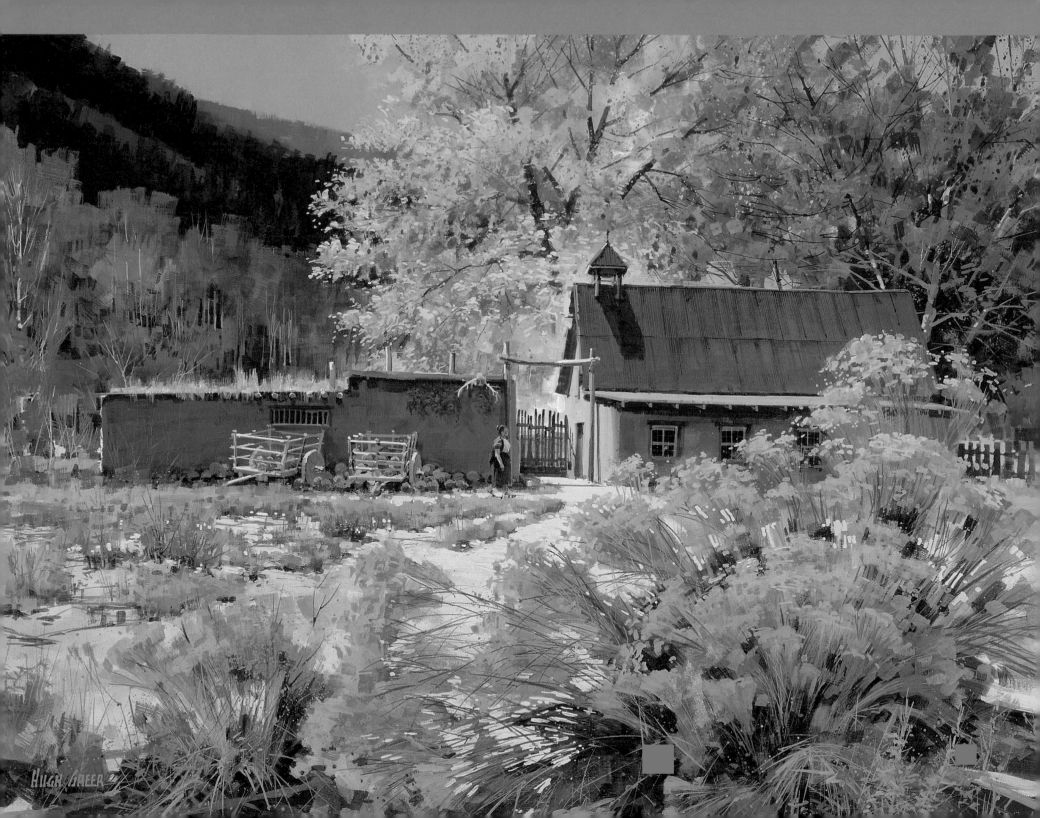

ACRYLIC

Paint

*A*crylic artist's paint is a newborn as far as artist's mediums are concerned. Approximately 50 years old, acrylics are becoming a popular medium because of their lightfastness, durability, flexibility and strength. The versatility of acrylic paint lends itself to many uses.

History

South of Santa Fe, New Mexico is the historic old settlement of Las Golandrinas. This site is several hundred years old and has lots of features to attract an artist's attention, like the old-fashioned mule-drawn carts at rest in front of this adobe structure.

Chapel at Las Golandrinas
Acrylic on Gessoed Masonite
18" x 24" (46cm x 61cm)

Acrylic Paint

Acrylic paint has been on the market since the 1940s. It has become a popular medium in part because of its ease of use and durability. Like watercolor, acrylics are water based, so you can thin your paint with water and clean up with soap and water. But that's not all—acrylics can also be used like oil paint to create impasto effects.

Sometimes temperature and humidity can cause a support to bend or move slightly, but that usually isn't a problem for acrylic paint, which is able to stretch on a properly prepared support. It is for this reason that in some tests, acrylics have withstood the test of time better than oil paint.

Because of their remarkable durability, acrylic paintings do not need to be covered with glass, like watercolor paintings. According to paint manufacturer Golden Artist Colors, Inc., their acrylics are "lightfast, permanent and flexible."

The paints used in all the examples throughout this book are Golden Fluid Acrylics. If you want to replicate the demonstrations you should purchase Golden Acrylics. These paints are sold in various quantities—one ounce all the way up to a gallon. I like using Golden because they manufacture professional-grade paints in a vast range of readily available colors. There are many different

brands and manufacturers of acrylic paints—you should experiment and find the brand that works best for you. Just make sure you use professional-grade paints.

As you will see when working through the exercises in this chapter, you can mix all of the colors you need from the limited base palette discussed in this chapter. You can pick any red, any yellow and any blue to create your own signature base palette. If you want to take some shortcuts, however, there are dozens of colors available in the heavy-body and the fluid viscosity.

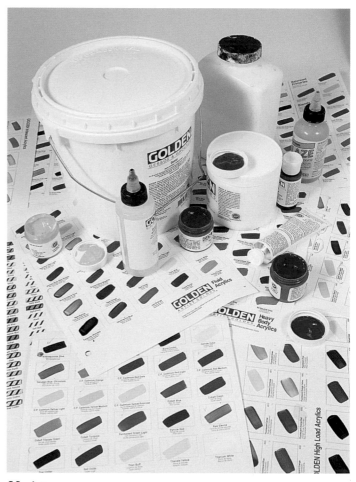

Variety

Acrylic paints come in a wide variety of colors and can be mixed with various mediums to create different textures and effects.

QUICK PAINT COMPARISONS

TASK	OIL	ACRYLIC	WATERCOLOR
Clean up	Turpentine	Water	Water
Durability	Moderate	High	Low
Soft edges	When wet	When wet	When wet
Dry time	Slow	Fast	Fast
Impasto effects	Yes	Yes	No

Heavy Body vs. Fluid Acrylics

Heavy Body Acrylics

When artist acrylics first hit the market, they were available only in a heavy-body formulation. Heavy Body Acrylics have a creamy quality that facilitates mixing, color blending and brushstroke retention. Heavy Body and Fluid Acrylics have the same amount of pigment per cubic inch; it is just that Fluid Acrylics are formulated to a thinner viscosity.

Fluid Acrylics

Fluid Acrylics were born when paint manufacturers saw that artists wanted a thinner viscosity acrylic paint that could be used to achieve watercolor effects while retaining the color richness they had come to count on in heavy-bodied acrylics. Fluid Acrylics are perfect for dry-brush techniques, detail work and staining, particularly on 100 percent rag watercolor boards. Fluid Acrylics by Golden are used for all the demonstrations in this book.

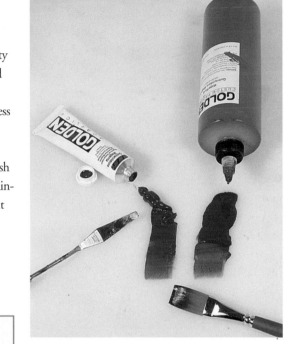

Viscosity

Notice how the heavy-bodied paint holds its shape until brushed out; the rich, creamy texture makes impasto effects possible. The Heavy Body Acrylic retains brushstrokes, which is an important paint quality for textured artwork. The Fluid Acrylic paint allows for fine detail work, dry-brush techniques and staining of the surface.

Qualities of Color

Base Palette

Diarylide Yellow

Anthraquinone
Blue

Cerulean Blue

Quinacridone
Magenta

Titanium White

Color has three qualities: hue, chroma and value. Hue is the name of the color, like red or blue. Chroma is the intensity of the color or how saturated it is. Value is the brightness or darkness a color is when compared to white or black.

Hue

Hue is another word for color. Red, yellow, green and blue are hues. Anthraquinone Blue and Cerulean Blue are different hues of blue. This chart shows the limited base palette used in exercises and demonstrations throughout the book.

Chroma

Chroma is known as the intensity of a color. It describes how brilliant or subdued the color looks. Within the yellow hue, a lemon has more chroma than a banana. The boxed colors show the high chroma colors; these colors are the pigment taken right out of the jar. The colors above the pure pigment are darkened with a mixed black (see page 34). White is added to the colors below the pure pigment.

Value

Value refers to a color's lightness compared to white, or darkness compared to black. Yellow is lighter in value, or closer to white, than dark green. Sometimes it is difficult to determine the value of midtoned colors like lavender and green. If you are having difficulty determining value, try squinting while looking at colors. Squinting helps the eye's black and white receptors make value determinations.

Where does the color get lost on the gray scale? This is its value.

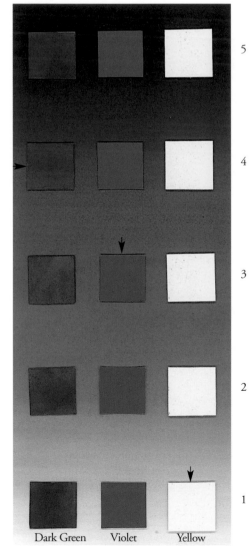

Dark Green Violet Yellow

The Color Wheel

In this exercise you will make a color wheel using the three primary colors and mixing them together to get a six-color wheel. It is optional to add Cerulean Blue, but it's a good idea to practice mixing with it. I find Cerulean Blue extremely useful for creating special grayed effects and sky colors. This exercise and the ones that follow will show you the variety of colors you can mix using only the three primary colors. If you do these charts, you'll be convinced of the limitless possibilities. And you will end up with charts showing you how you got there! The charts you created through mixing these colors may come in handy later if you ever have a commission because they will enable you to match the interior color scheme. Also, they look pretty hanging around your studio and will impress your non-artist friends.

Remember to mix with a palette knife to keep the colors as clean as possible. You can use your brush to transfer the colors to paper.

The Expanded Palette

Use these alternate colors to add to or substitute for the limited base palette. It is a shortcut and can really save you time by not having to mix your own colors. However, it's best for a beginner to use fewer colors and mix them in order to achieve a harmonious painting. You will want to stick to the base palette at first, then gradually add one or two colors.

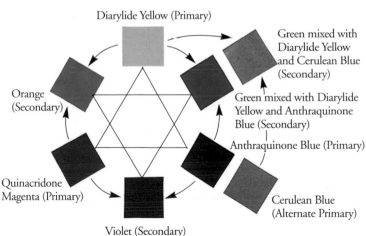

Diarylide Yellow (Primary)

Green mixed with Diarylide Yellow and Cerulean Blue (Secondary)

Green mixed with Diarylide Yellow and Anthraquinone Blue (Secondary)

Anthraquinone Blue (Primary)

Cerulean Blue (Alternate Primary)

Violet (Secondary)

Quinacridone Magenta (Primary)

Orange (Secondary)

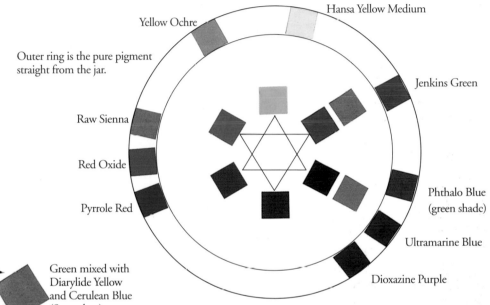

Hansa Yellow Medium

Yellow Ochre

Outer ring is the pure pigment straight from the jar.

Raw Sienna

Red Oxide

Pyrrole Red

Jenkins Green

Phthalo Blue (green shade)

Ultramarine Blue

Dioxazine Purple

Mixing Secondary Colors

Use the limited base palette (shown on page 32) to mix secondary colors. Use approximately a 50:50 ratio to come up with the secondary colors. You should eyeball it to decide what works for you. Or pick any three primaries and create your own palette.

Mixing Black

Mixed blacks are very important. Some great artists use the pigment black in their palette and have been very successful. What I have found, however, is that after eliminating the pigment black from my palette and mixing my own, I get richer and more vibrant colors. The colors I use do not contain the pigment black, except for Jenkins Green, which does contain a small amount of black pigment in the paint itself. Colors dry darker than they appear when wet, but don't worry because it is easy to compensate for this.

Mixing Black

You can learn to mix a really dark black by following these *general* proportions: approximately fifty percent Anthraquinone Blue, forty percent Quinacridone Magenta, and ten percent Diarylide Yellow. There is no exact formula to follow; it has to be eyeballed.

Using Mixed Black to Make a Gray Scale

While working on the gray scale and color charts, concentrate on the exercise of mixing colors rather than on an absolutely perfect value scale. You won't be graded; this is where "just pretty" counts. It's important to familiarize yourself with actually mixing paint in the exercises in this chapter. We will use this value scale throughout the book. It will particularly be useful in chapter three when we discuss value scales.

STEP 1 *Make a Gray Scale*

Using the black you just made, brush out a scaled wash. Place your black at the top of your paper and Titanium White at the bottom. While wet, blend together. Use a medium-spray bottle to keep things wet.

STEP 2 *Use a Template*

Create a 1" (25mm) square template out of paper using a straightedge ruler and a pencil. When the paint is dry, use the template to draw at least five squares along the continuum of your graded wash.

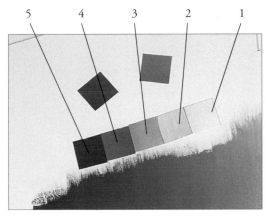

Final

Cut out the squares of color you delineated in the previous step.

Select five values that represent the scale. The darkest value, which is almost black, is value no. 5. Next, choose the lightest value, which is almost white; this is value no. 1. Now pick the one in the middle for no. 3. At this point, it's usually easy to spot nos. 4 and 2. Place the five evenly spaced grays at the top of a piece of white mat board. We will talk more about this value scale in chapter three and refer to it throughout the book.

Shading and Tinting

The five-point gray scale is used to evaluate the chroma of each of the six colors (or seven colors if you are using Cerulean Blue). The high-chroma colors are placed under the appropriate value on the gray scale.

The previously mixed black is added to darken the colors. The boxed squares of color point out the six (seven) high-chroma colors. All the colors to the left of the pure chroma have been mixed with black. This is called *shading*. Anthraquinone Blue is close to black in value, therefore you only need to shade once to get to the darkest value.

White is added to lighten colors. Titanium White is added to create the colors to the right of the pure pigment. This is called *tinting*. Because Diarylide Yellow is close to white in value, you only need to tint it once to get the lightest value. Each of these colors originated from the three primary colors straight out of the jar.

Line Up Colors on the Gray Scale

When you line up the colors on the gray scale you are able to see their value and how the values relate to one another. The heavy box in each row indicates pure pigment and where its value falls on a five-point gray scale.

	5	4	3	2	1
Gray Scale					
Diarylide Yellow (Primary)				▣	
Green mixed with Diarylide Yellow and Anthraquinone Blue (Secondary)			▣		
Anthraquinone Blue (Primary)					
Cerulean Blue (Alternate Primary)			▣		
Violet (Secondary)					
Quinacridone Magenta (Primary)		▣			
Orange (Secondary)			▣		

Grayed Colors

Warm and cool grays can add a lot of depth and subtlety to your paintings. You can create beautiful grays by using the mixed black from page 34 made from the three primaries. This black can be added to each primary and secondary color and then tinted with white to create a variety of colors.

Line up your darkest value of each color as shown. The darkest values are lined up on the vertical strip under value no. 5.

Another value wash is added using Titanium White only. Again, this is called tinting. It's these warm and cool grays that make a painting come alive. We will be talking about warms and cools in later demonstrations.

The Gray Scale

Creating warm and cool grays can add a lot of beauty and depth to your painting. Use the mixed black (see page 34) previously created from the three primaries and combine it with each primary and secondary to create gray. Add white to this gray to create different tints. Notice the low chroma compared to the pure pigments found on page 36.

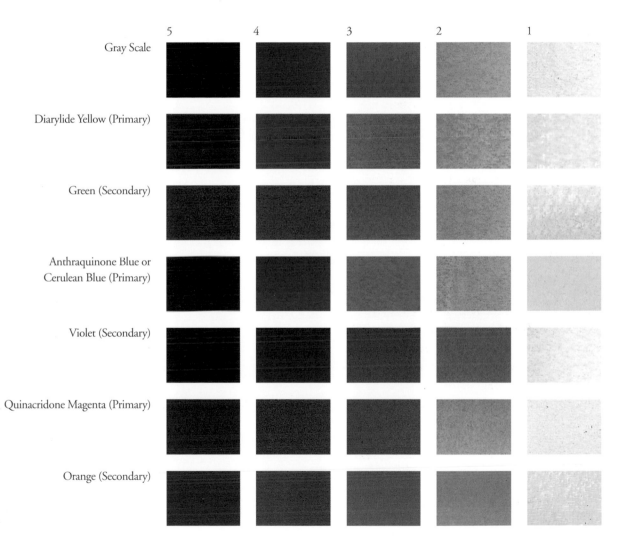

Using the Base Palette

ACRYLIC PAINTS
Anthraquinone Blue
Cerulean Blue
Diarylide Yellow
Quinacridone Magenta
Titanium White

BRUSHES
One-stroke brushes: ⅛-inch
(3mm), ¼-inch (6mm),
½-inch (12mm), ¾-inch
(18mm), 1-inch
(25mm) and 1½-inch
(38mm)
Script brushes: nos. 1 and 2

**ADDITIONAL
SUPPLIES**
Crescent Illustration board
no. 1, 18" x 24" (46cm
x 61cm)
Palette
Palette knife
Paper towels
Water

Using the base palette is fun and easy. Try this mini-demonstration to practice your color techniques.

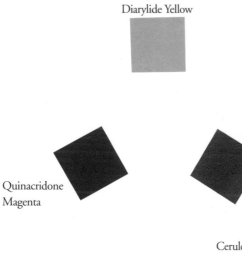

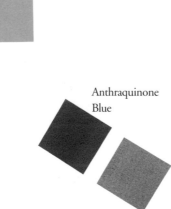

Diarylide Yellow

Anthraquinone Blue

Quinacridone Magenta

Cerulean Blue

Titanium White

The Base Palette

The base palette has all the colors you need to begin painting.

PRACTICE MIXING COLORS

There is no substitute for practice. Color mixing will become second nature as you hit upon colors that work and repeat them in subsequent paintings.

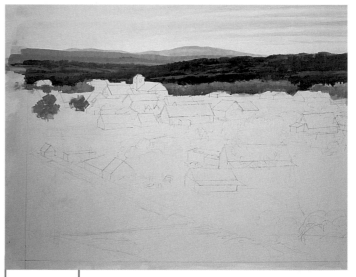

STEP *1* *Apply a Wash and Paint the Mountains*

Use Crescent Illustration board no. 1 for your support. Paint a thin wash of Quinacridone Magenta and Diarylide Yellow to coat the board. Lay in the mountains using Cerulean Blue, Anthraquinone Blue and Titanium White with just a touch of Quinacridone Magenta. Use the same blue for all the mountains, but add more white as they recede.

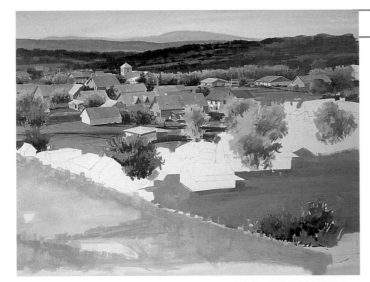

STEP 2 | *Develop the Painting*

For the sky, use Cerulean Blue and Titanium White with a touch of Diarylide Yellow. For the autumn trees, use Diarylide Yellow with a touch of purple created from Quinacridone Magenta, Anthraquinone Blue and Titanium White. Paint the field with a tan made with Quinacridone Magenta, Diarylide Yellow, Cerulean Blue and Titanium White.

STEP 3 | *Add Details*

The roof color was mixed by combining Quinacridone Magenta, Diarylide Yellow, Cerulean Blue and Titanium White. Use approximately fifty percent red, ten percent yellow and forty percent white. For a shaded red you can add a touch of Anthraquinone Blue.

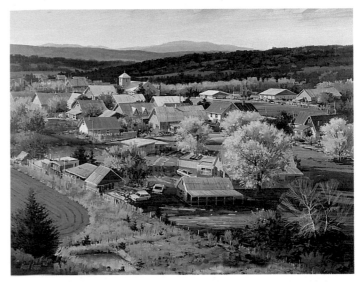

Final

The strong reds and yellows mixed into the other colors throughout this painting give you a feel for the evening light. A blue-violet influences the shaded sides and shadows.

Northern New Mexico October
Acrylic on Crescent Illustration board no. 1
18" x 24" (46cm x 61cm)

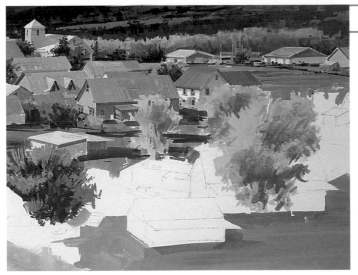

Create Your Own Palette

This particular palette is great for winter scenes because the colors are soft—the Yellow Ochre and Red Oxide are already grayed. Experiment using this color palette or create your own using other primary colors.

Yellow Ochre

Red Oxide

Ultramarine
Blue

Titanium White

Winter Palette

Use this palette to create winter scenes.

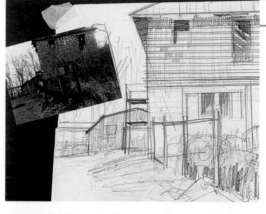

STEP *1* | Sketch and Transfer

Make a sketch from this photograph and transfer it to the Gessobord.

STEP *2* | Tint the Board

Coat the entire Gessobord with a mixture of Red Oxide and Yellow Ochre. Trace your sketch onto the dried undercoating.

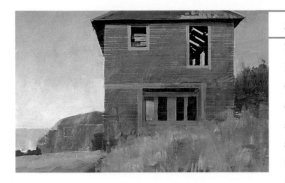

STEP 3 | *First Layer*

Use Ultramarine Blue for the sky. Paint the grasses with Yellow Ochre. The building is a translucent glaze with opaque color all around; the initial undercoating shows through. Paint the winter trees with a mixture of Ultramarine Blue, Red Oxide and a small amount of Titanium White.

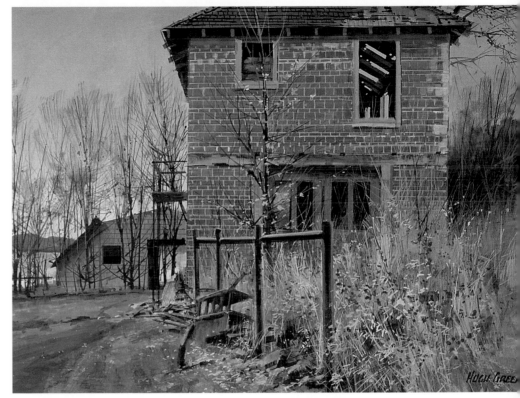

STEP 4 | *The Field*

Use Yellow Ochre and Titanium White to paint the distant field. The color of this building is a mixture of Yellow Ochre, Red Oxide, Titanium White and a touch of Ultramarine Blue. The winter green is made with Yellow Ochre and Ultramarine Blue with touches of Red Oxide and Titanium White.

STEP 5 | *The Trees*

Create the trees using a mixed black.

Final

In the base palette of Red Oxide, Yellow Ochre and Ultramarine Blue, the red and yellow are already grayed as they come out of the jar. This makes a great base palette for winter colors.

Neodesha Relics
Acrylic on Gessobord
9" x 12" (23cm x 30cm)

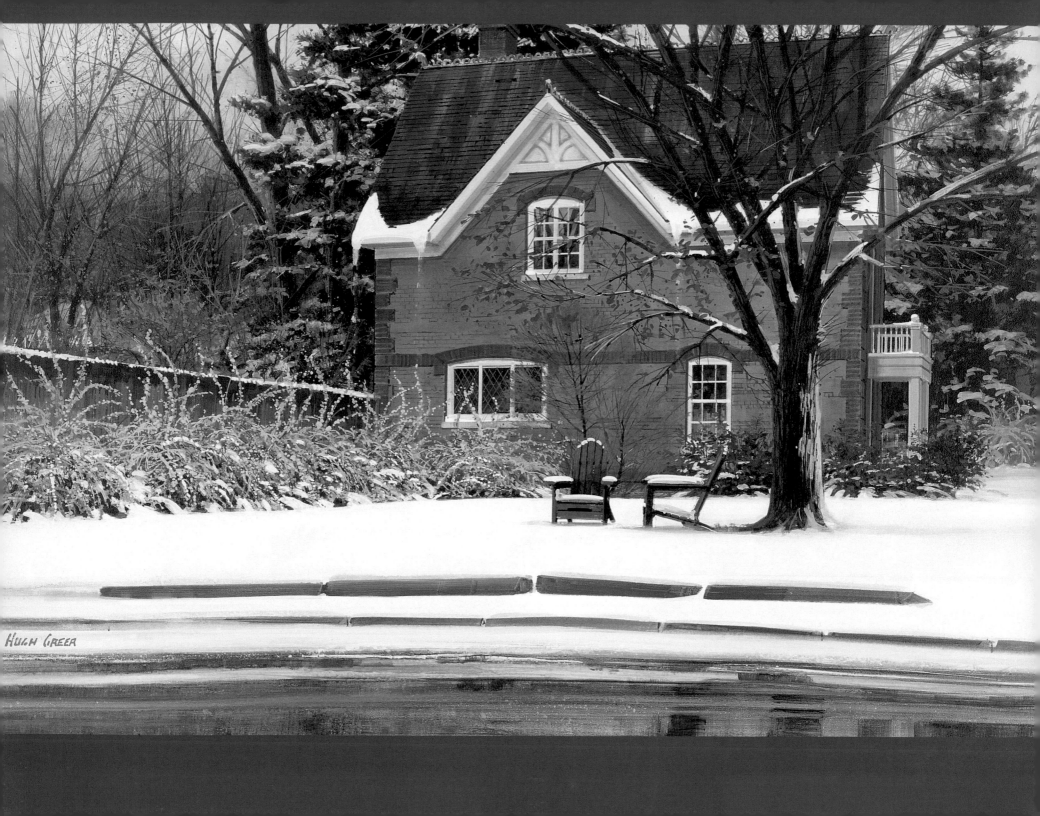

CREATING SPECIAL EFFECTS WITH A VARIETY OF

Techniques

*I*n the last chapter you saw how a very limited base palette could produce a wide range of colors through mixing. Color, of course, is a major component in any composition, but this chapter goes beyond color to look at different painting tips, tricks and techniques. You can use the special effects as you see them presented here or in any combination. Like color mixing, experimenting with various techniques is the best way to see what works for your own style. I hope working through these exercises will stimulate your thinking and encourage you to further develop your own repertoire of techniques.

April Fool

I woke up on April 1 to find all of nature's newly blooming shrubs covered with a fresh layer of snow. This snowy blanket, the last remnant of winter, creates a novel contrast to the evidence of budding spring. And it was fun to paint as well.

April Fool
Acrylic on Crescent Illustration board no. 1
15" x 22" (38cm x 56cm)

Value Curtains

The value curtain technique teaches you to think in layers. Remember the five-point value scale from chapter two? Here's another way to use it in planning a painting from foreground to the farthest point in your scene. This process encourages you to see anew the relationship of the parts of the scene to the scene as a whole and assign them a value number. A pencil sketch to work out values before color work may boost your confidence.

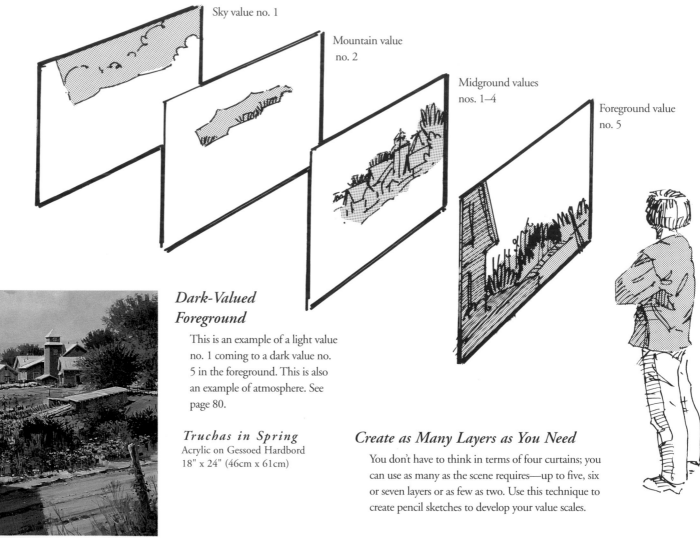

Sky value no. 1

Mountain value no. 2

Midground values nos. 1–4

Foreground value no. 5

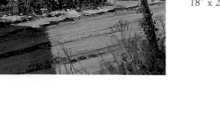

Dark-Valued Foreground

This is an example of a light value no. 1 coming to a dark value no. 5 in the foreground. This is also an example of atmosphere. See page 80.

Truchas in Spring
Acrylic on Gessoed Hardbord
18" x 24" (46cm x 61cm)

Create as Many Layers as You Need

You don't have to think in terms of four curtains; you can use as many as the scene requires—up to five, six or seven layers or as few as two. Use this technique to create pencil sketches to develop your value scales.

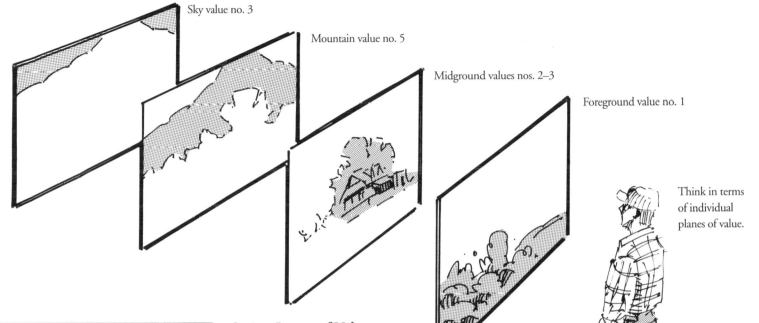

Sky value no. 3

Mountain value no. 5

Midground values nos. 2–3

Foreground value no. 1

Think in terms
of individual
planes of value.

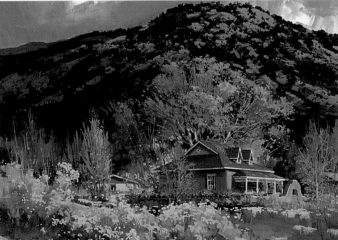

Seeing Layers of Value

Approaching a painting in terms
of curtains or planes of value can
be a handy practice. This is an
example of value no. 5 coming
from the background toward the
foreground value no. 1.

Season Before Winter
Acrylic on Gessoed Hardbord
12" x 16" (30cm x 41cm)

The Layered Value Scale

Remember our five-point value
scale from chapter two? Here's
another way to use it in planning
a painting from foreground to
the farthest point in your scene.
This is a thought process and can
be applied to a pencil sketch.

Understanding Light Sources

It's important to identify the light source for consistency in highlighting and shadowing. The following examples of light falling on houses and trees illustrate how different light sources cast shadows. Compare these paintings to one another to gain a greater understanding of light, shade and shadows.

Shade Reflected light into shade Shadow Light Light source

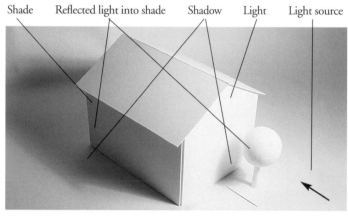

Light Perpendicular to the Viewer

The light source is perpendicular to the viewer thereby illuminating one surface. Bright sunshine lights up the front facade of this building. Notice the strong shadows and reflected light.

Reflected light into shade Shadow Strong light Shade

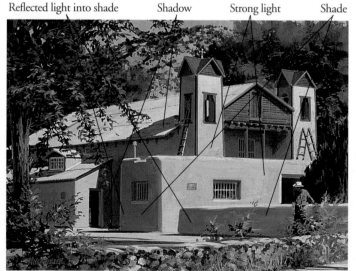

Notice how dark the house is. The highlight on the tree shows the effect of backlighting.

Light source Shade Reflected light Shade

Shadow

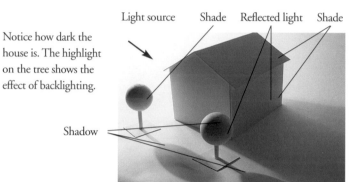

Light Coming at the Viewer

When the subject is between the viewer and the light source, you have backlighting. This can be the most dramatic lighting of all. One of the reasons for its drama is that the subject (center of interest) is illuminated against a contrasting background. Some artists specialize in this type of lighting in their paintings.

Dark background Translucent leaves and flowers Dark shadows

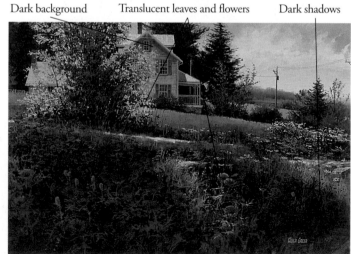

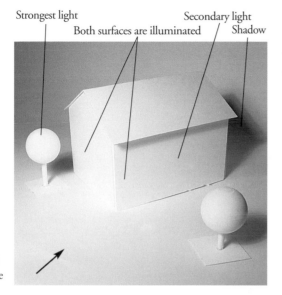

Strongest light

Both surfaces are illuminated

Secondary light

Shadow

Light source

Light Coming From Behind the Viewer

The light source is behind the viewer looking toward the subject resulting in illuminated multiple surfaces. The long shadows are typical of late evening.

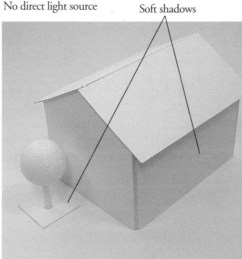

No direct light source

Soft shadows

Diffused Light

Overcast days produce the diffused lighting in which artists often prefer to work. The soft shadows and overhead lighting create a more subtle effect than backlighting. Diffused lighting means a soft light source from above; this creates light shadows and values toward the midrange. Notice how close in value everything is. There are no hard-edged shadows here.

Strong light

Secondary light

Shadow

Middle value colors—not a lot of strong contrasts

Softer shadows

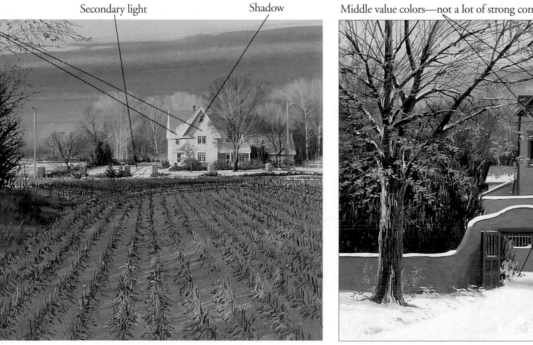

Light at Various Times of Day

In each of these pictures, notice how the Redbud tree and the shadows change throughout the course of a day. These photos are of The Lodge, property of Dave and Kelli Brown, Wichita, Kansas.

Pale yellow light Long shadows

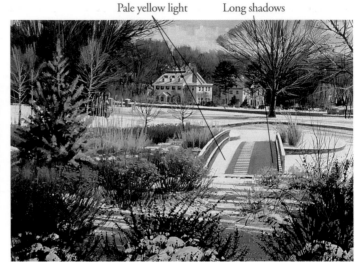

Morning

Light from straight above Short shadows

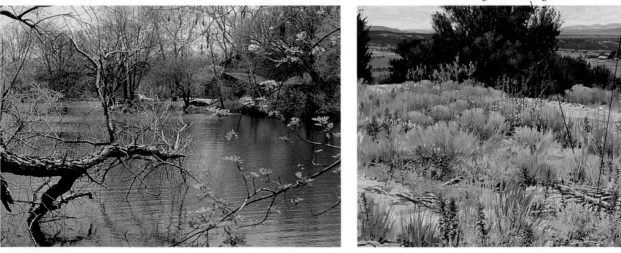

Midday

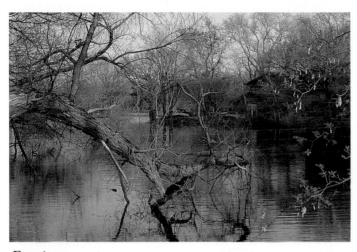

Evening

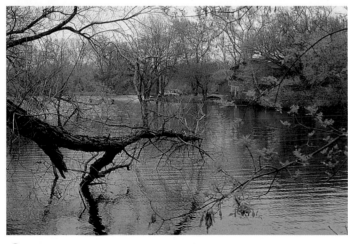

Overcast

Long shadows Pale orange light

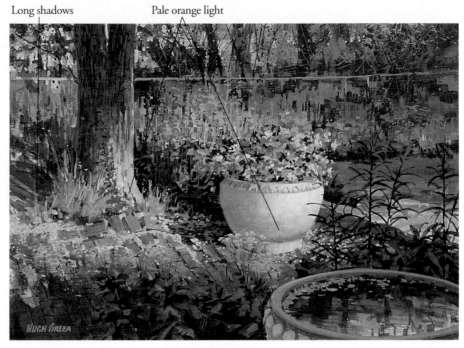

Soft shadows Middle scale values Grayed sky

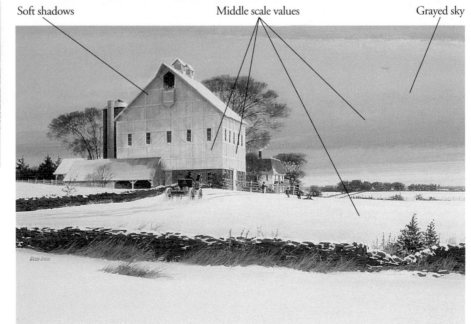

Washes, Glazes and Tints

Washes, glazes and tints are used to create various colors and effects dependent on the color combinations and number of layers you paint. Try these simple exercises to become familiar with washes, glazes and tints. Lay down as many different colors and layers of glazes and washes as you wish.

Purple-blue wash (let dry between layers)

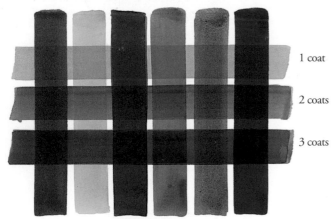

1 coat

2 coats

3 coats

Purple-blue glaze (let dry between layers)

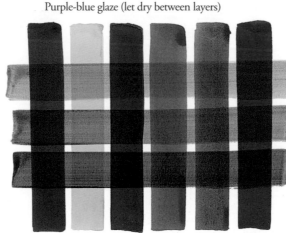

1 coat

2 coats

3 coats

White wash or tint (let dry between layers)

1 coat

2 coats

3 coats

Washes

A wash is a mixture of paint and water. Mix some colors at random and wash on a midvalue color. The same color was used for each of the horizontal purple-blue strips; the second and third strips are darker because multiple washes were applied.

Glazes

Mix some colors at random and add a glazing medium, like Golden Soft Gel, to create a glaze. Artists use glazes when they want luminous color. The same color was used for each of the horizontal purple-blue strips; the second and third strips are darker because multiple layers were applied.

Tints or White Washes

Tints or white washes are made with pigment lighter than the color you're painting on. Even though straight white was used in a diluted form in this example, you can see how it has changed the color. Mix some colors at random and lay down a three-color wash of Titanium White.

Layering to Create Three Dimensions

MATERIALS LIST

ACRYLIC PAINTS
 Diarylide Yellow
 Red Oxide
 Titanium White

BRUSHES
 One-stroke brushes: ⅛-inch
 (3mm), ¼-inch (6mm),
 ½-inch (12mm), ¾-inch
 (18mm), 1-inch
 (25mm) and 1½-inch
 (38mm)
 Script brushes: nos. 1 and 2

**ADDITIONAL
SUPPLIES**
 Crescent Illustration board
 no. 1, 9" x 12" (23cm x
 30cm)
 Palette
 Palette knife
 Paper towels
 Soft Gel (optional)
 Water

Try this easy step-by-step exercise to practice layering with washes or glazes. You will be amazed at the wonderful effects you can create using this technique.

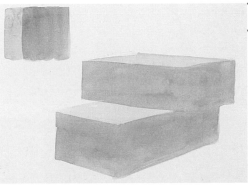

STEP 1 Apply a Thin Wash

Use either a wash or glaze of Red Oxide combined with a small amount of Titanium White and Diarylide Yellow. Apply one thin wash to the white board to create a few shapes as shown in the picture.

STEP 2 Apply a Second Coat

Using the same color as in step one, mix a wash or glaze using slightly less water or gel. This value will be darker because there is more pigment. When the first coat is dry, apply a second coat to the areas as shown in the picture.

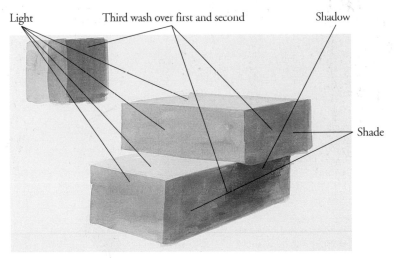

Light Third wash over first and second Shadow

Shade

Final

After the second coat is dry, apply a third one of the same color to the areas as shown in the picture. You will need another coat after this one dries to further delineate the shadowed area on the right under the top brick. All of this was done with the same color.

Layering in Reverse

Creating reversed layers is another technique using washes. You can create form by layering subsequent washes at varying intensities. Placing a light-colored wash over a dark ground is one way to layer. This is a great exercise for working with negative space.

STEP *1* | *Initial Dark Wash*

On either Crescent Illustration board no. 1 or gessoed Masonite (or any heavy-weight paper), apply a wash made from Red Oxide, Diarylide Yellow and Titanium White.

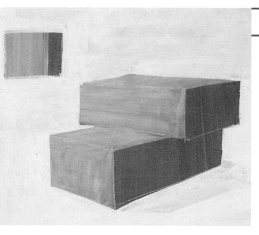

STEP *2* | *Paint the Negative Space*

Using a heavy-pigmented white wash, paint the negative space; then use a thin wash of Titanium White to lay in a wash on the top and left sides. This is the area the light is striking.

Third wash or Titanium White

Do not apply the wash here to indicate shaded area.

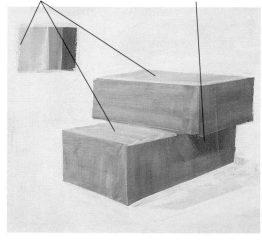

Final

Using the same thin wash of Titanium White used in step two, apply a third wash only on the top, avoiding the shaded area on the right side. This creates the strongest light on the shapes.

Applying the Wash First—Still Life

Applying an underwash to your painting allows the color to show through your painting. This can create a unifying color theme to your painting.

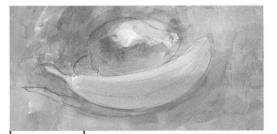

STEP 1 *Apply the First Glaze*

Lightly sketch in a banana and a pear. Wash or glaze a gessoed panel or Crescent Illustration board no. 1 with the red color that is in the pear. Leave areas of white where you think the highlights will be. Working dark to light will help tie the colors together allowing the base color to show through.

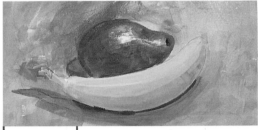

STEP 2 *Apply a Darker Red Glaze*

It may be helpful to refer to the color charts you did in the previous chapter. Glaze the pear with darker reds. Red color should come through the banana. Glaze the banana with darker yellows. Use a red-blue in the shadow.

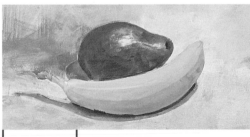

STEP 3 *Apply a White Wash*

Paint the background (negative space) with a white wash or glaze in several thin layers. Allow the red to show through.

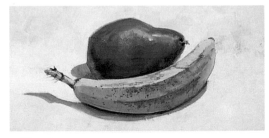

Final

Put the finishing touches on the banana and pear. Apply a thin layer to the background. At this point you can make the background any color you want or leave it white.

Unity—Color Harmony Using Washed Backgrounds

Underpainting with a colored wash is another way to tie things together and create mood resulting in a harmonious painting. These examples are done on Crescent Illustration board no. 1 because it allows for many washes and glazes before the one-hundred percent rag surface becomes filled with polymer.

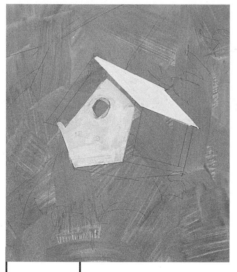

STEP 1 Tonal Wash

Paint the whole board with a warm light color. White wash the front facade and use an off-white wash for the roof.

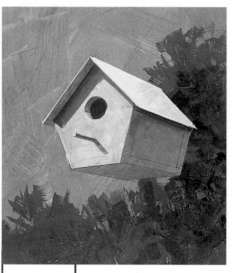

STEP 2 Basic Shapes

Mix Anthraquinone Blue into the off-white color for the shadows. Notice how the background color is still showing. Lay in the green trees over the warm background.

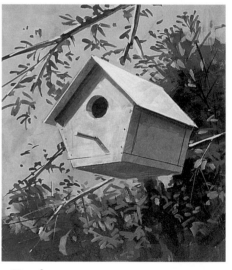

Final

Paint the sky with Cerulean Blue and Titanium White; the warm background should still show through.

Luminosity—The Stained Glass Window Effect

You don't have to paint a stained glass window to use this luminescent effect. Luminosity relies on light coming at you or from within the subject such as the petal of a flower, leaves or anything transparent that is getting light from the back. Unfortunately, one of the things lost from the original art to the printed page is luminosity.

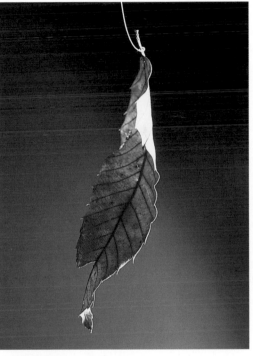

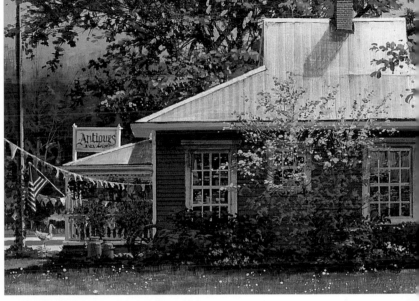

Backlighting Creates Transparency

Notice the leaves on the tree between the two windows. With backlighting, leaves become transparent.

Kechi Antiques
Acrylic on gessoed Masonite
9" x 12" (23cm x 30cm)

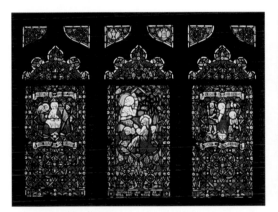

Luminescence

All of the colors in this piece are bright and transparent. You create this effect by using a high-pigment color mixed with a glazing medium.

Stained Glass Window
St. James Episcopal Church, Wichita, Kansas

Backlighting and Luminescence

Under ordinary lighting conditions you probably wouldn't call the color of this dead brown leaf pretty (that's reserved for fall leaves), but look what happens with backlighting.

Controlled Splatters

How do you control a splatter? Well, you can't always have complete control, so first of all, don't wear your best clothes. This technique is worth practicing because putting splatters into a painting will actually break up flat areas of color and give the illusion of detail. After splatters are on the surface of your painting, you can use your spray bottle—one shot of mist—to slightly break up the drips and keep them from looking mechanical.

Splattering Is Easy and Fun

Creating splatters is easy. Cover any areas you don't want splattered. Load your brush with fluid paint and grip it between your thumb and middle finger. Gently tap the brush with your index finger above the area of your painting where you want splatters. Try different-sized brushes for various sized droplets.

Splattering Supplies

When splattering, you will need: masking fluid, an old brush, inexpensive tracing paper and drafting or masking tape.

FLUIDITY

The fluidity of the mixture should be according to your desired effect. Practice on plain paper before you splatter your painting.

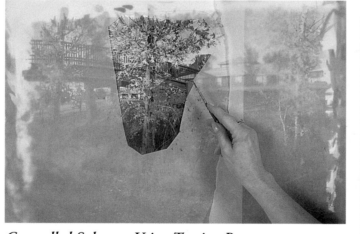

Controlled Splatters Using Tracing Paper

Tracing paper is a convenient tool for adding splatters because you can see the painting through the paper. Draw an outline on the tracing paper of the area you want to receive splatters and cut out. When you cover the painting with the piece of tracing paper from which you removed the outlined area of the object that will be splattered, the painting behind the tracing paper will be protected. Don't make the mistake of thinking splatters won't go onto any unprotected section of your painting. You don't have that much control.

Splatters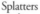

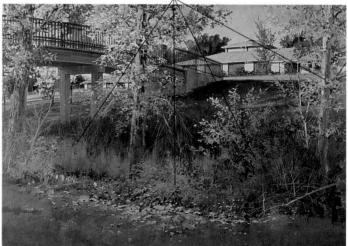

Use a Brush to Define Splatter

After the splatters are dry, you can go in with your ⅛-inch (3mm) one-stroke or script brush to indicate leaves. The splatters will act as a guide.

Spanning the Gap
Acrylic on Crescent Illustration board no. 1
16" x 21" (41cm x 53cm)

Splatters

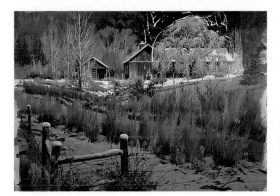

Controlled Splatters Using Masking Fluid

All of the roughed-in areas were done with ½-inch (12mm) and ¾-inch (19mm) one-strokes. After the paint is dry, brush masking fluid around the shape of the tree.

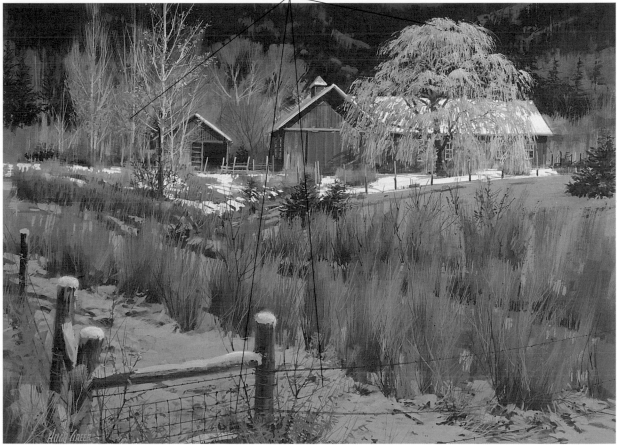

Last Light in the Valley
Acrylic on Crescent Illustration board no. 1
18" x 24" (46cm x 61cm)

Splattering Over Masking Fluid

Lay tracing paper over the parts of the painting you want to protect. If you leave a portion of the painting uncovered as in this example, you may end up seeing some unwanted spots. Load your brush with fluid paint, and with your index finger gently tap the brush above your painting.

Water Hound

Some splatters can be made by your best friend—I don't recommend these for painting.

Painting Negative Space

Painting the negative space allows you to paint your subject in a luminous fashion (see page 55) and cut out the shapes with opaque paint. Some magical things happen when you paint this way. You can discover this for yourself. Almost all paintings have negative space in them.

Painting the Negative "Back and Forth"

The tree behind the barn was painted with a transparent technique and then the hill behind it was painted, cutting in the shapes of the tree and barn. Forward for more detail to the tree, then back again to the hill and barn; thus, the back and forth or negative space technique.

Lilac Bush and Atchison Barn
Acrylic on Gessoed Hardbord
8" x 10" (20cm x 25cm)

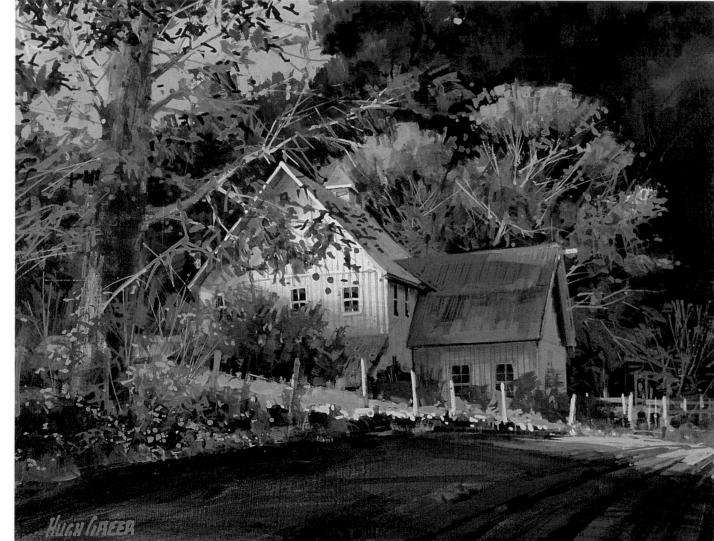

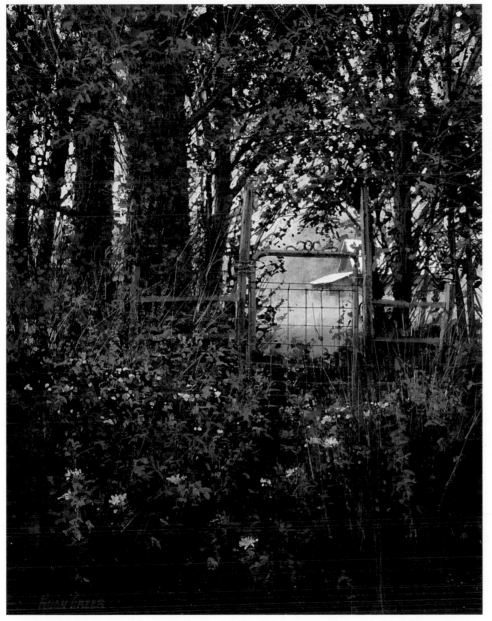

Painting "Dark" Negative Space

The center of interest in this painting is the light green tree in the midground and flowers in the light underneath the green tree. The dark negative spaces are everywhere. Without them, the center of interest would not appear to be so bright.

Santa Fe Courtyard
Acrylic on Gessoed Hardbord
9" x 12" (23cm x 30cm)

Painting "Light" Negative Space

This is a high-contrast painting using both ends of the value scale: no. 5 in the foreground and no. 1 in the background. The viewer is standing in the shadows of the trees looking out to an open field filled with morning light. The light background was washed in first and the trees were painted over that, allowing the light to sneak past the breaks between the trees. The light punches in negative space "holes" in the mass of trees. (See Creating Atmospheric Depth, page 80).

Shortcut
Acrylic on Crescent Illustration board no. 1
12" x 9" (30cm x 23cm)

Center of Interest

The center of interest in every painting is where your eye stops to rest before traveling throughout the rest of the painting and back again to the first spot. There can be more than one center of interest, but we will concentrate on only one per painting. There are three basic ways of creating a center of interest: color, line or a combination of both.

Line as the Center of Interest

Sometimes it's fun to bend the rules and place the center of interest outside the center. The old stone fence points like a dagger to the barn in the upper right. From the barn, your eye travels along the fence row to the pond, back to the stone fence post and back again, always returning to investigate the details in the barn.

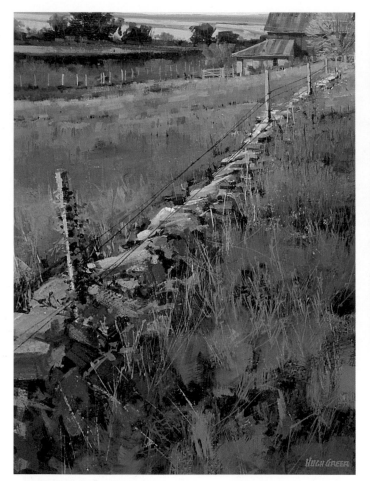

Denying Time, Spring
Acrylic on Gessoed Hardbord
12" x 9" (30cm x 23cm)

Color as the Center of Interest

Strong color attracts your eye and serves as a focal point. The bright red flower of the geranium plant draws your eye into the painting.

Southwest Geranium
Acrylic on Gessoed Hardbord
12" x 16" (30cm x 41cm)

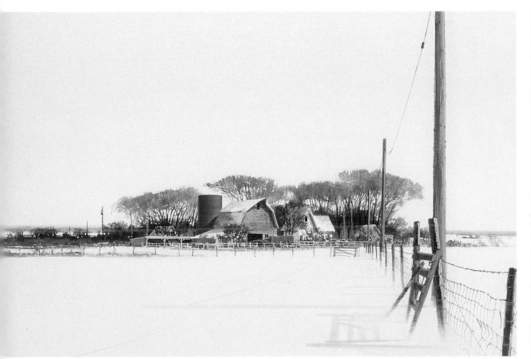

Line and Color Combined

The strong dark colors against the white of the sky and snow help to establish the center of interest. This painting is more about line work and composition than it is about subject matter. Without the strong lines, there would be no center of interest. Fence posts and fencing, electric lines and the horizon line all work together to draw your eye to the center of interest.

The Red Gate
Acrylic on Crescent Illustration
board no.1
10" x 16" (25cm x 41cm)

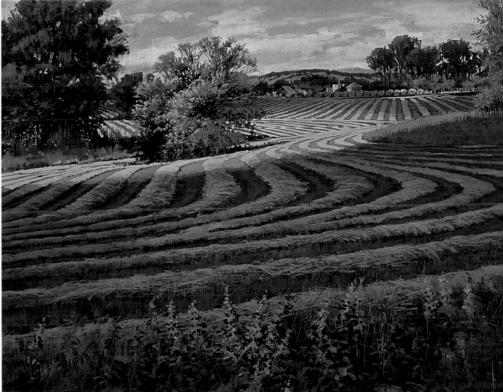

Line and Color Combined

This is a freshly mowed field, and the patterns of cut hay lead your eye to the center of interest that is highlighted by the sun on the golden tree. Even the flowers in the foreground point to the center of interest.

Patterns of Summer
Acrylic on Gessoed Hardbord
18" x 24" (46cm x 61cm)

Trees

It is a good idea to study deciduous trees in the winter when their skeletal qualities are easy to see. You'll get a feel for the variety of sizes, shapes and forms—the structures—that support the summer foliage. Even though you may find interesting and unusual trees, try to pick forms that are recognizable and unique. The most unusual trees may not always translate into a believable painting.

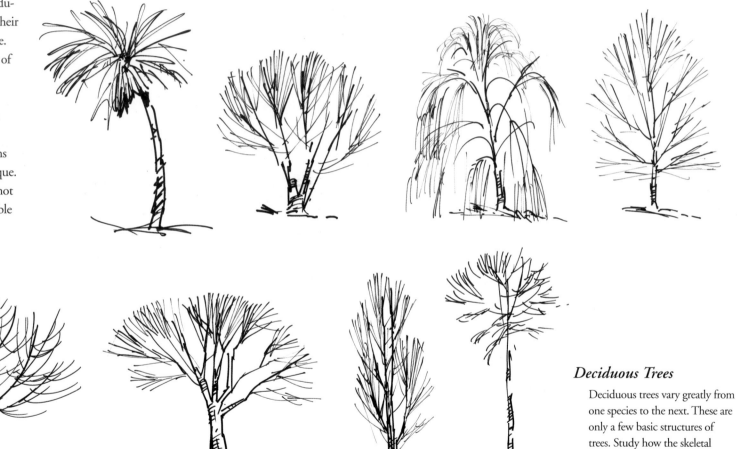

Deciduous Trees

Deciduous trees vary greatly from one species to the next. These are only a few basic structures of trees. Study how the skeletal structure of the deciduous trees varies from those of the coniferous trees on the opposite page.

Coniferous Trees

Coniferous trees come in all shapes and sizes. They are also known as evergreens because they keep their needles throughout the year. They also have a very distinct skeletal structure.

Tree in the Evening Light

Sometimes it's fun to try to create detail with a larger brush than usual. Here we will try to capture the setting sun using a ¾-inch (18mm) one-stroke.

STEP *1* | *Wash the Board*

Use a big brush, a ½-inch (12mm) or ¾-inch (10mm) one-stroke, to wash the board with orange made with Quinacridone Magenta, Diarylide Yellow and Titanium White. With a paper towel, make a swipe to establish a horizon line. Remember the sky is lighter toward the horizon than at the top of the painting. Soften the sky area with the paper towel so the sky is lighter than the ground.

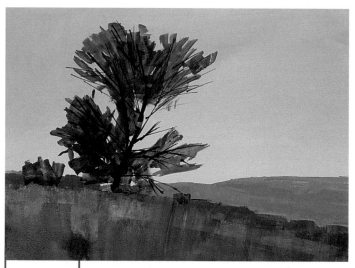

STEP *2* | *Paint the Tree*

Mix some Dioxazine Purple into the background orange used in step one and use it to paint the tree skeleton with a ⅛-inch (3mm) one-stroke. With a ½-inch (12mm) one-stroke turned on its edge, add foliage to give the tree shape. Leave some holes in the foliage to allow the sky to show through. Avoid filling the tree with leaves, which would make it look like a lollipop. Add the distant mountain and some green where the grasses and wildflowers will be.

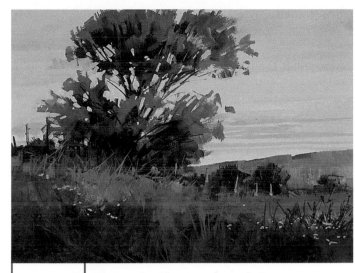

STEP 3 | *Paint the Sky, Leaves and Grasses*

Paint the sky behind the tree with Cerulean Blue and Titanium White. While it is still wet, wipe some off with a paper towel, exposing some base orange for the clouds at sunset. Make sure you place some sky in between the branches of the tree.

Mix a green with Diarylide Yellow and Anthraquinone Blue. Put that to the side and mix another orange similar to the original wash but more opaque (thicker) using Quinacridone Magenta, Diarylide Yellow and Titanium White. Combine the newly mixed green and orange, making a green-orange. This new green-orange will be your highlight color for the leaves and grasses. Add leaves to the tree, being sure to leave some holes so the sky can show through the tree. Add highlights to the leaves with your green-orange color.

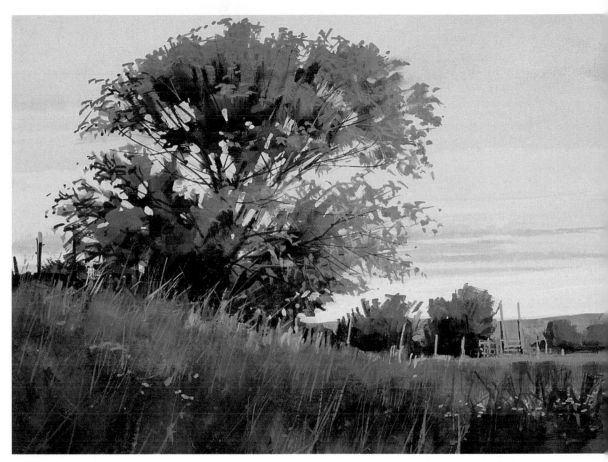

Final

Darken and define the foreground grasses using a script brush, palette knife, ruling pen, paper towel, finger tip or anything else that works. The grass and tree color are the same. Chop down the hill on the right using opaque orange. Darken the shadows in the foreground. Add the fence posts.

Flint Hills Elm
Acrylic on Crescent Illustration board no. 1
8" x 10" (20cm x 25cm)

CREATE HARMONY

The fence posts, grass highlights and leaf highlights are all the same color. This helps create color harmony within the painting.

Painting Trees with a Small Script Brush

MATERIALS LIST

ACRYLIC PAINTS
Anthraquinone Blue
Cerulean Blue
Diarylide Yellow
Jenkins Green
Quinacridone Magenta
Titanium White

BRUSHES
One-stroke brushes: ⅛-inch
 (3mm), ¼-inch (6mm),
 ½-inch (12mm), ¾-inch
 (18mm), 1-inch
 (25mm) and 1½-inch
 (38mm)
Script brushes: nos. 1 and 2

**ADDITIONAL
SUPPLIES**
Crescent Illustration board
 no. 1, 8" x 10" (20cm x
 25cm)
Drafting or masking tape
Masking fluid
Old brush
Palette
Palette knife
Paper towels
Scissors
Soap
Tracing paper (inexpensive)
Water

You can create form and shape using cross-hatching. Use a small script brush, either nos. 1 or 2, to paint the trees in this mini-demonstration.

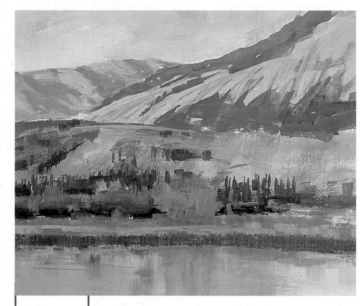

STEP *1* | *Paint a Low-Value Landscape*

Using the base palette plus Jenkins Green, paint a basic landscape keeping most of the colors low in value—a 1, 2 and 3 on the five point value scale.

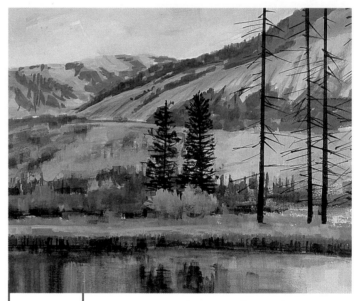

STEP *2* | *Add Tree Trunks*

Mix Jenkins Green, Anthraquinone Blue and Quinacridone Magenta to create a very dark green. Use a ⅛-inch (3mm) one-stroke and a script brush to paint in the pine tree skeletons. Because of their dark nature, you can place the pine trees over the background color.

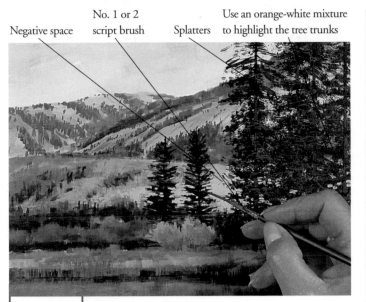

Negative space
No. 1 or 2 script brush
Splatters
Use an orange-white mixture to highlight the tree trunks

STEP 3 | *Develop the Trees*

Add some pine foliage with your script brush and some splatters using the same dark green. To highlight the foliage, mix Diarylide Yellow, Anthraquinone Blue and a touch of both Quinacridone Magenta and Titanium White. This highlight color will also be dark—in the nos. 3 to 4 value range. To highlight the tree trunks, mix Quinacridone Magenta, Anthraquinone Blue, Diarylide Yellow and a touch of Titanium White.

Paint in the negative space to create a bright spot just beyond the twin trees in the midground. This will help create the center of interest.

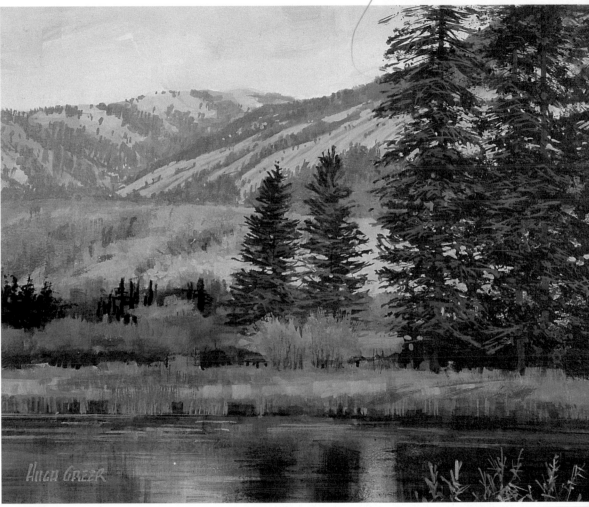

Final

Use the same colors you used in step three as a wash for the pond reflections. Soften the area vertically with a paper towel. A light-spray bottle is handy here to keep the surface wet while you work it. Paint some highlights with a no. 1 or 2 script brush. Add some brushwork.

Blanco Basin Pond
Acrylic on Crescent Illustration board no. 1
8" x 10" (20cm x 25cm)

Painting Redbud Trees with a Ruling Pen

The ruling pen is a great tool for detail. The biggest advantage is the ability to lay on an intense bead of pigment rather than the thin film of pigment you get from a brush.

MATERIALS LIST

ACRYLIC PAINTS
Anthraquinone Blue
Cerulean Blue
Diarylide Yellow
Quinacridone Magenta
Titanium White

BRUSHES
One-stroke brushes: ⅛-inch
(3mm), ¼-inch (6mm),
½-inch (12mm), ¾-inch
(18mm), 1-inch
(25mm) and 1½-inch
(38mm)
Script brushes: nos. 1 and 2

**ADDITIONAL
SUPPLIES**
Alcohol and cotton swab
Ballpoint pen
Crescent Illustration board
no. 1, 8" x 10" (20cm x
25cm)
Drafting or masking tape
Lift-out tool
Masking fluid
Old brush
Palette
Palette knife
Paper towels
Ruling pen
Saral paper or pastel stick
Scissors
Soap
Tracing paper (inexpensive)
Water

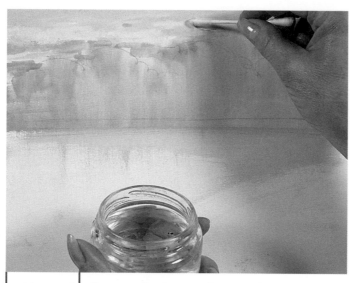

STEP 1 | Create a Background

Paint the blue sky and orange sunlit background trees at the same time so the edges soften where they meet. Wipe the excess paint off the background trees with a paper towel, getting a vertically streaked effect. When this has dried, mix a purple-blue for the underside or shady side of the clouds. Let this dry; use a cotton swab dipped in isopropyl alcohol and gently lift out areas directly above the shadows of the clouds.

STEP 2 | Paint the Trunks and Branches

Use your script brush and ruling pen to put in the trunks and branches of the background trees; the sun is hitting the tops of the trees, so use lots of Titanium White with a touch of Diarylide Yellow. The redbuds are mostly in the shade, but the sun setting in the background is hitting the very tops of the trees. Use the script brush and a ⅛-inch (3mm) one-stroke to apply a mixed dark color for the redbud trunks and limbs. Sketch the lawn furniture on tracing paper and transfer it using Saral paper or pastel stick onto the grassy area.

STEP 3 | *Use the Ruling Pen to Paint the Buds*

Mix a very dark mixture of mostly Quinacridone Magenta, Cerulean Blue, Anthraquinone Blue and a little Titanium White for the color of the redbuds in the shade. Use the ruling pen to dot in the buds; making small strokes with the ruling pen will also do the job. Splatters are appropriate to help speed up the process of painting all those buds! Remember to protect parts of the painting where you don't want splatters.

CONTRAST

Redbuds are one of the first trees to show their colors in the spring. Most of the other trees have not yet started to turn green, so the contrast can be quite striking.

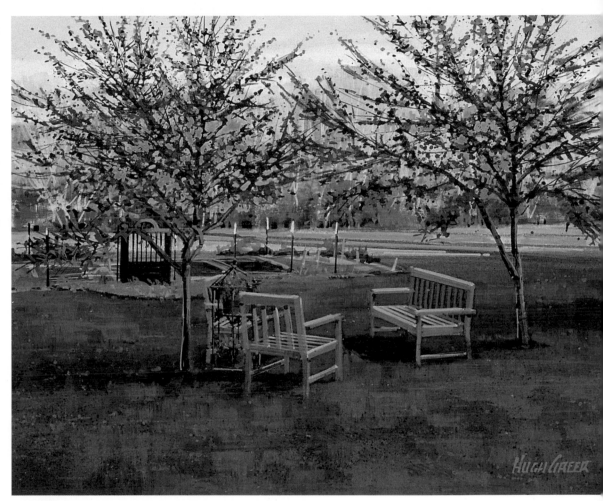

Final

The buds that are in the sunlight are a mix of Diarylide Yellow, Quinacridone Magenta and Titanium White. Put this color in with a ruling pen. Develop the lawn furniture and the grassy foreground, and you're done.

Redbud Trees in Early Spring
Acrylic on Crescent Illustration board no. 1
8" x 10" (20cm x 25cm)

Painting Aspens With a Wide Brush

Aspen trees are loved for their tall, straight, pristine appearance. They color up beautifully in the autumn and are a knockout to see. Most artists who see them have to paint them. Here's your chance.

STEP *1* | *Sketch and Mask*

Start by sketching onto your board. Mask out the tree trunk areas with masking fluid.

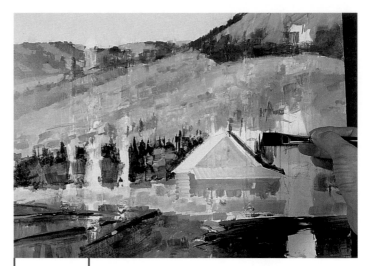

STEP *2* | *Paint the Aspens and Pine Trees*

Brush in the background aspens using Yellow Ochre, Diarylide Yellow and Titanium White, graying it slightly with a touch of Dioxazine Purple. Being a hazy day, there are no bright brights. The green areas are also grayed slightly with a touch of Dioxazine Purple and are brushed and blended into the yellow with a ¾-inch (10mm) one-stroke while wet. Work quickly and use a medium-spray bottle to extend your drying time. Work wet-into-wet to get soft edges.

The pine trees behind the barn are brushed in using the edge of a ½-inch (12mm) one-stroke. Use a mix of Dioxazine Purple and Jenkins Green with a touch of Anthraquinone Blue. The same green is used for the foreground. Let all this dry and remove the masking fluid.

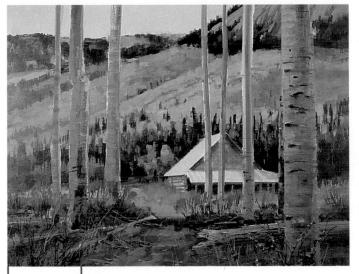

STEP 3 | *Develop the Trees*

The aspen tree trunks are a slightly greened gray. Mix a black using the base palette, but go heavier on the blue and yellow. Now add a little bit of this mix to your Titanium White and see if you get a greened gray. You may need to adjust your proportions to get a good aspen tree trunk color. Brush this color in vertically, up and down the trunk. Splatter the foreground and work in sticks, leaves and foliage using a script brush and a ruling pen. Let this dry.

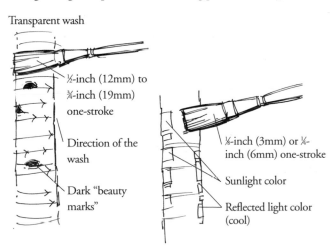

Transparent wash

½-inch (12mm) to ¾-inch (19mm) one-stroke

Direction of the wash

Dark "beauty marks"

⅛-inch (3mm) or ¼-inch (6mm) one-stroke

Sunlight color

Reflected light color (cool)

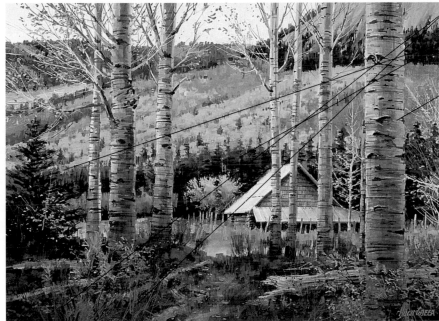

Palette knife

Script brush used to highlight pines

Reflected light color

Ranch in Blanco Basin
Acrylic on Gessoed Masonite
12" x 16" (30cm x 41cm)

Final

The sunlit leaves in the foreground aspen are a mix of Diarylide Yellow with touches of Quinacridone Magenta and Titanium White. The darker leaves are a color mixed from Diarylide Yellow and Dioxazine Purple. Splatter these leaves in and refine them with a script brush. Use a ⅛-inch (3mm) or ¼-inch (6mm) brush for the highlights on the aspen trunks, mixing a color of mostly white with a little yellow for the sunny side of the aspens. There is some reflected light on the trunks (see illustration). The reflected light is put in with the greened gray color you used for the aspens, plus a little Cerulean Blue and Titanium White added to cool it for the shaded side of the trees. Add more splatters and use your palette knife, brushes and other tools to create the illusion of detail.

Create the center of interest by contrasting the bright roof and bright golden aspen with the dark of the pine trees.

Grasses and Wildflowers

This demonstration will give you lots of tips and tricks for painting realistic vegetation. This scene is typical of the Midwestern United States, particularly the sunflowers, dead grasses, bright weeds and wildflowers. Lots of things to make you sneeze.

MATERIALS LIST

ACRYLIC PAINTS
Anthraquinone Blue
Cerulean Blue
Diarylide Yellow
Dioxazine Purple
Jenkins Green
Quinacridone Magenta
Titanium White

BRUSHES
One-stroke brushes: ⅛-inch (3mm), ¼-inch (6mm), ½-inch (12mm), ¾-inch (18mm), 1-inch (25mm) and 1½-inch (38mm)
Script brushes: nos. 1 and 2

ADDITIONAL SUPPLIES
Alcohol and cotton swab
Ballpoint pen
Bridge
Gessoed Masonite 18" x 24" (46cm x 61cm)
Drafting or masking tape
Lift-out tool
Masking fluid
Old brush
Pencil
Palette
Palette knife
Paper towels
Ruling pen
Saral paper or pastel stick
Scissors
Soap
Soft Gel
Tracing paper (inexpensive)
Water

MIST YOUR PAINTINGS

Just as I start to work the panel, I'll use my light-spray bottle and mist the surface of the panel to help the paint flow more smoothly.

STEP 1 | Apply a Transparent Wash

Brush a mixture of pale orange made with Diarylide Yellow and Quinacridone Magenta with a touch of Cerulean Blue and Titanium White onto the board in a random pattern. While still wet, use a paper towel to give it a vertically streaked texture. After this dries, use some soap and water on a paper towel to wash off some of the smears in the lower areas of the painting. The foreground is going to have transparent washes applied to it, and you won't want a dark smudgy color to interfere. Rinse thoroughly and allow it to dry. Sketch the painting on tracing paper and transfer it onto the Masonite using Saral paper or pastel stick.

STEP 2 | Paint the Grass

The grassy area in the foreground is a stronger mixture of orange (Quinacridone Magenta and Diarylide Yellow) with a touch of Cerulean Blue to slightly gray the mix. This is a dead grass color. The greener grass and weeds are a mixture of Diarylide Yellow, Jenkins Green and a touch of Quinacridone Magenta. We want to give this a more alive look. Mixing a wash of the orange-brown color, paint the foreground and while still wet, use the lift-out tool to indicate grass texture.

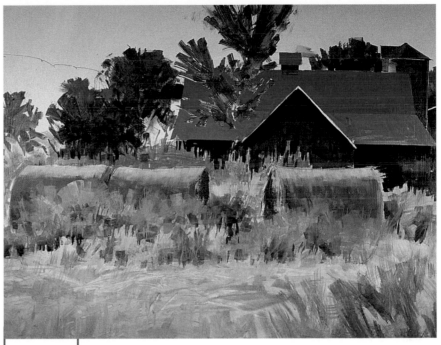

STEP 3 | *Paint the Bales of Hay*

Create a mixture of Anthraquinone Blue and Dioxazine Purple. Add a small amount of this mixture to the orange color for the bales of hay; this will gray it and give it shading. Notice how the bottoms of the bales are darkened to make the weeds in front stand out. As you work the foreground green bushes and grass in front of the bales of hay, use the spray bottle a lot. When you lay in the darker greens, wipe the brush out and blend the dark green into the light.

STEP 4 | *Add the Trees and Barn*

Paint the trees with a mixture of Jenkins Green, Anthraquinone Blue and Diarylide Yellow. You may want to add a touch of Quinacridone Magenta. Add a small amount of Anthraquinone Blue, Titanium White and Diarylide Yellow to Quinacridone Magenta to create a mixture that is mostly red and block in the barn using the bridge for the straight edges (see The Bridge page 20).

CREATE CONTRAST

Notice how the bottoms of the bales are darkened to make the weeds in front stand out.

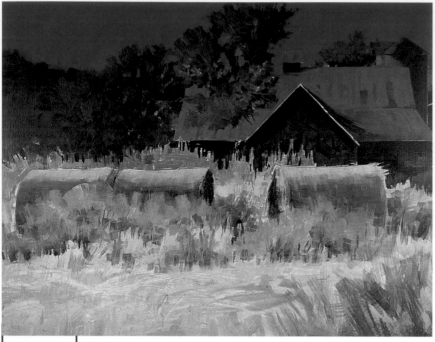

STEP 5 | *Paint the Hill and Sky*

Paint the background hill and sky. The hill is a mix of the base colors that lean towards the Anthraquinone Blue. The sky is darker than the barn roof but lighter than the hill. Use some of the hill color to paint shadows on the barn roof and the silo. I've chosen a very dark setting to make the foreground grasses and flowers stand out. Everything in the background is going to have a lot of Anthraquinone Blue in the mix.

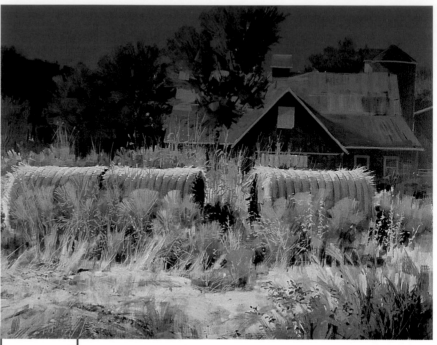

STEP 6 | *Add Detail*

Now it's time for the script brush and ruling pen. You will want to further develop the grasses with lighter tones and darker shadowed areas. A few splatters, particularly in the background trees, are in order. Use a cotton swab dipped in isopropyl alcohol to very carefully lift out highlights on the tops of the bales of hay.

CREATE UNITY

When you finish step five, analyze the painting. You may want to wash it down with a very thin wash (ninety percent water and ten percent pigment) of a dark blue to unify the colors. Use very thin washes so you can intensify the wash as needed by applying more washes.

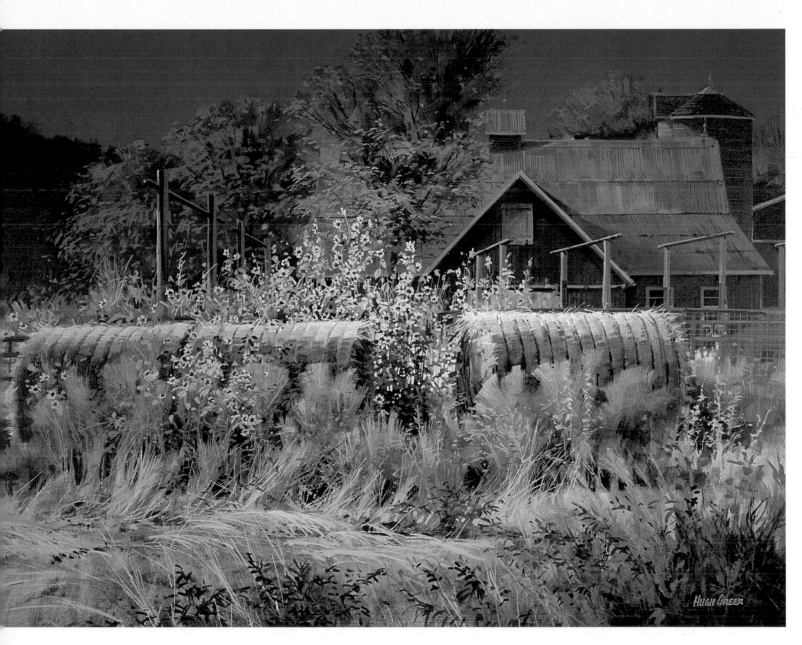

Final

Using a no. 2 script brush, put in the sunflowers with an opaque color mixed from a combination of Diarylide Yellow, Titanium White and Dioxazine Purple. When dry, create a lighter mixture of Diarylide Yellow and Titanium White and place it on the petals to highlight them. For the center of the flowers, try a mix of Diarylide Yellow and Dioxazine Purple. Use the flat edge of a ¼-inch (6mm) one-stroke to put in the leaves on the sunflowers.

Paint in the cattle-loading pens with a dark color mixed from the base palette. Use a warm color on the sides with light and a cool color on the shaded sides.

Summer's Last Hurrah
Acrylic on Gessoed Masonite
18" x 24" (46cm x 61cm)

Cumulus Clouds

Since the lighting in your painting comes from the sky, it is important to create a believable one. Usually when something is wrong with a landscape, the first place to look is the relationship between sky and ground. Unless you're painting a skyscape, don't overdo the sky, particularly if there are a lot of other things going on in the painting. In other words, a plain, simple sky—maybe just blue—can be the best. Let's look at a few approaches to tackling clouds.

STEP 2 | Spray the Board

After the warm wash is dry, use the spray bottle to wet the surface just enough for individual beads to stand up. Don't overdo it, or you'll have to wait until it dries and then start over. You need the beads of water. Into the beads or drops of water, put a sky blue wash in the shape of the cloud you want. The blue color should jump from drop to drop creating a lacy look. Allow this first cloud-shaping wash to dry.

STEP 1 | Apply a Wash

On a piece of Crescent Illustration board no. 1, apply a graded wash with pale yellow at the top and a slightly darker orange toward the bottom. Allow to dry completely.

PAINTING CLOUDS

As clouds recede into the distance, the white part becomes warmer while the landscape becomes cooler and lighter. The larger the cloud, the darker its bottom.

STEP *3* | *Spray Again*

Repeat the process in the previous step: spray with water so beads develop, apply wet pigment, watch the color jump from drop to drop. Now mix some gray for the undersides of the clouds. Make the gray from a mixture of the sky blue and a little orange. Work a little of the gray into the wet droplets. Expose the warm color down close to the horizon by using a lift-out tool.

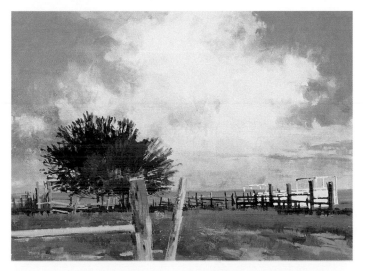

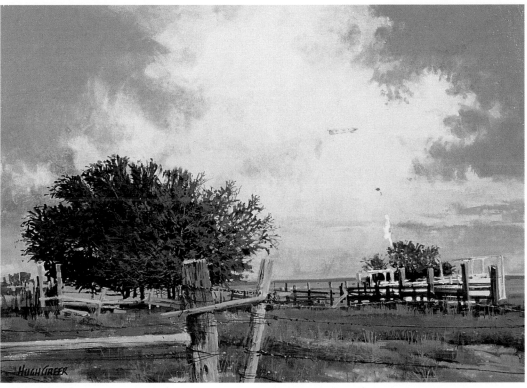

Cattle Chutes
Acrylic on Crescent Illustration board no. 1
9" x 12" (23cm x 30cm)
See *Storm Over the Prairie* (page 121).
Notice how the same scene changes
depending on the lighting and
atmospheric conditions.

Final

The success of this procedure depends on your ability to capitalize on accidents. Work out the finishing elements of the cattle chutes, fence posts and trees.

Storm Clouds

Early morning and late evening thunderheads can be a spectacular sight with the warm colors that usually highlight the tops of the clouds.

STEP 1 | Apply a Wash

Wash the Crescent Illustration board no. 1 with a vivid orange (a blend of Diarylide Yellow and Quinacridone Magenta). Allow the wash to dry. Use a paper towel to lift out places where the highlights or transparent areas will most likely be.

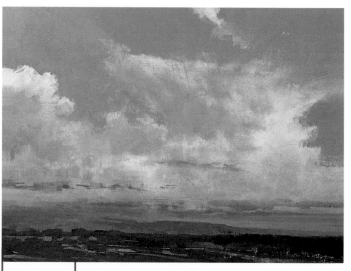

STEP 2 | Use a Lift-Out Tool

For the shadowed side of the clouds, mix Cerulean Blue, Titanium White, Quinacridone Magenta and a bit of Diarylide Yellow to gray it. Use a lift-out tool in the foreground.

SOFTENING EDGES

A light-spray bottle was used to soften edges while the Cerulean Blue and Titanium White areas were brushed into the negative space creating the cloud shapes.

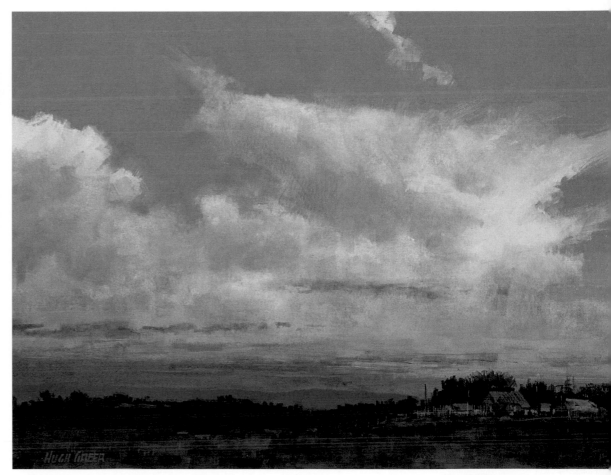

STEP 3 | Paint Thin Washes

Use thin washes in a dry-brush effect for the thin, wispy tails coming off the main thunderhead.

Final

Add orange to the clouds and purple to the horizon line to intensify the sense of impending rain.

Looking Towards the Opera
Acrylic on Crescent Illustration board no. 1
9" x 12" (23cm x 30cm)

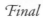

Creating Atmospheric Depth

Creating depth in a painting will give the viewer a sense of space and perspective. Atmospheric layering is one way to achieve depth in your landscapes.

STEP 1 | Apply the Wash and Transfer the Drawing

Use an orange wash mixed with the base palette. Apply the wash to the support—darker at the bottom, lighter at the top. Let this dry. Sketch and transfer your drawing onto the support.

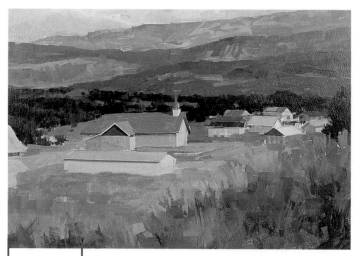

STEP 2 | Paint the Mountains

Depth and atmosphere is going to be created in the mountains behind the chapel. You can see the layered effect of the mountains as they appear to recede (the colors become cooler and lighter). Leave some spots of the undercoat showing through in the mountains. Keep the background mountain colors grayed so they are not strong and vibrant. The foreground colors should be a higher chroma and have a more intense color.

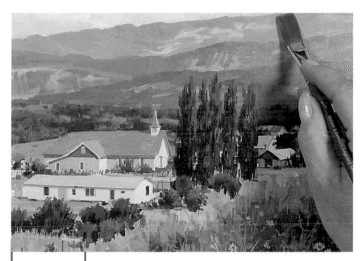

STEP 3 | *Develop the Painting*

Create a wash of Titanium White and Soft Gel with a tiny bit of
Anthraquinone Blue. Apply a thin wash of this mixture over the
mountains; this will soften them further, adding more atmosphere.
The low hill behind the chapel is darker, providing a nice contrast
to the red roof of the chapel and creating a center of interest. Paint
the poplar trees with the edge of a ¼-inch (6mm) one-stroke loaded
with a mixture of Jenkins Green and Dioxazine Purple. The poplar
trees are the darkest part of this painting. Highlights on the poplar
trees are from a mix of Jenkins Green, Diarylide Yellow, a touch of
Quinacridone Magenta and Titanium White.

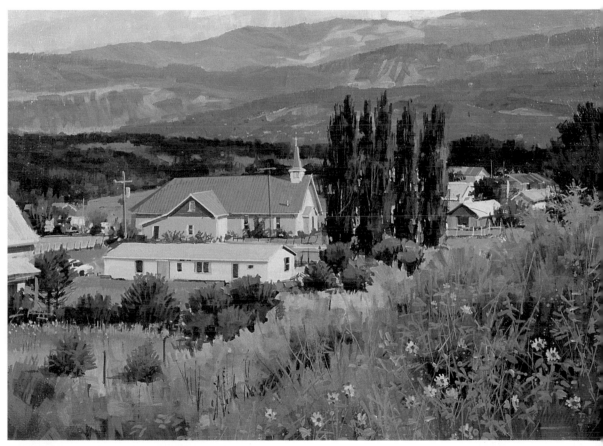

Final

Embellish the foreground with sunflowers, telephone poles, grasses,
weeds and shadowed areas. Brighten the sky if you like.

Church at Rowe
Acrylic on Gessoed Hardbord
9" x 12" (23cm x 30cm)

Roads

Roads are arteries connecting us to one another. On them we travel home, venture off on vacation and conduct the business of daily life. Without them, we'd be pretty isolated. Many of my paintings are of places I encountered while traveling. Quite a few places have "no trespassing" signs on the property—no problem—in that situation, I just pull my car off to the side of the road and start painting. Often the road itself becomes part of my painting and sometimes leads into the center of interest.

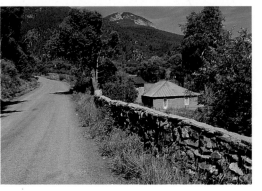

Reference Photo

I'm using a photo from my file that I know will present a challenge to me because of its composition. The photo was taken on a bright sunny day on a mountain road in northern New Mexico. However, I would like to depict it on an overcast day with fresh rain on the pavement.

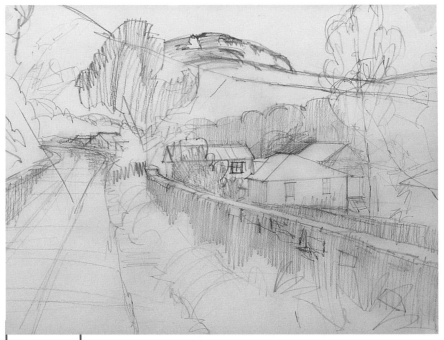

STEP *1* | *Create and Transfer Your Sketch*

Make a sketch on a 12" x 16" (30cm x 41cm) piece of tracing paper. Transfer your drawing to Gessoed Hardbord, and you're ready to paint. Leave the surface white; no need to underpaint here. After the tracing is transferred to the support, coat the surface with Soft Gel Gloss to keep the line work from smearing when applying washes over it. This coating will also allow the paint to stand on the surface a bit longer before drying, making it easier to blend colors.

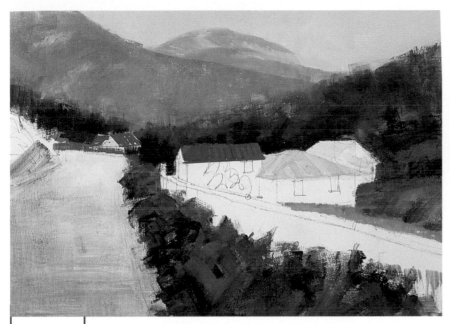

STEP 2 | *Lay in the Painting*

Begin laying in some of the big shapes. Mix the sky, mist and mountain colors with combinations of Ultramarine Blue, Red Oxide and Titanium White. You will be using these grays for the reflective road as well. This combination of colors is used in several places throughout the painting to help unify it. For the rooftops use Red Oxide, Quinacridone Magenta, a touch of Diarylide Yellow and as much Titanium White as necessary to lighten the roofs just enough to catch the eye and make them the center of interest. For the foliage, use a combination of Diarylide Yellow, Ultramarine Blue and Jenkins Green. Remember, the background foliage will be lighter in value so soften and gray the foliage in the background (a no. 1 or 2 on the value scale). The foreground foliage will be darker and higher in value (no. 4 or 5 on the value scale) and the chroma will be more intense.

STEP 3 | *Streak the Painting*

Use a paper towel to vertically pull the paint toward the bottom of the support, leaving streaks in the wet paint for a wet appearance.

STEP 4 | Develop the Road

Use a dry, ½-inch (12mm) one-stroke to lift pigment off the road. Create a bright white spot at the end of the road where it bends to the left to achieve balance with the bright spot in the sky. As the road comes toward you, it will be darker because there is more reflective light in the distance. You want the center of interest to be the houses, so the red roofs will come in handy to draw your eye there.

Use a mixture of Ultramarine Blue, Red Oxide and Titanium White for the loose gravel on the side of the road and the asphalt.

Slightly less Slightly more Equal The centerline is half of the road width

STEP 5 | Perfect the Curve of the Road

Make a careful study of the curve on tracing paper to get the perspective right.

STEP 6 | Use the Ruling Pen

Transfer the sketch of the road onto a piece of mat board and cut it out as a guide for the ruling pen. Make sure to sand the rough spots on the mat board before you use it to create the center line.

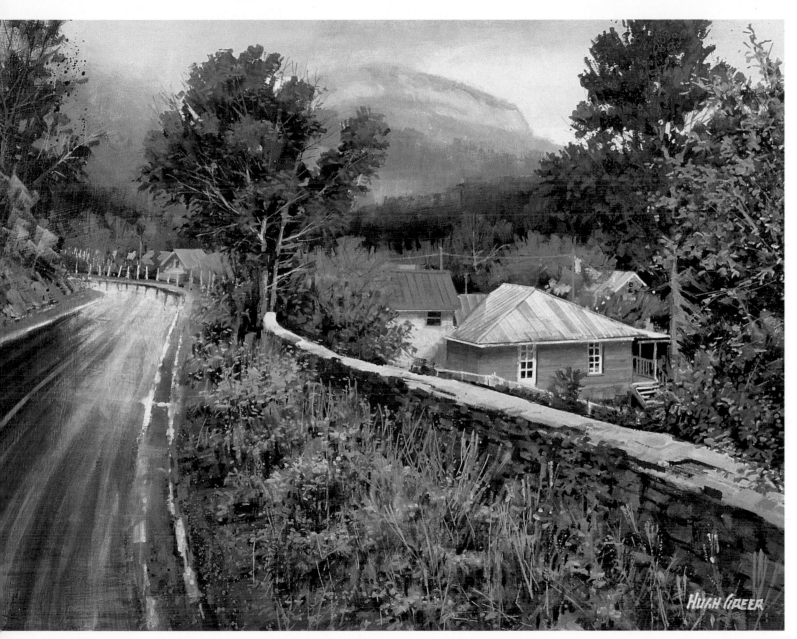

Final

Apply several layers of blue washes to the road using vertical and horizontal strokes. The dark blue on the left is a result of the trees on the side of the hill reflecting onto the pavement.

Add detail to leaves, trees, grasses and wildflowers to complete the painting.

Road 230
Acrylic on Gessoed Hardbord
12" x 16" (30cm x 41cm)

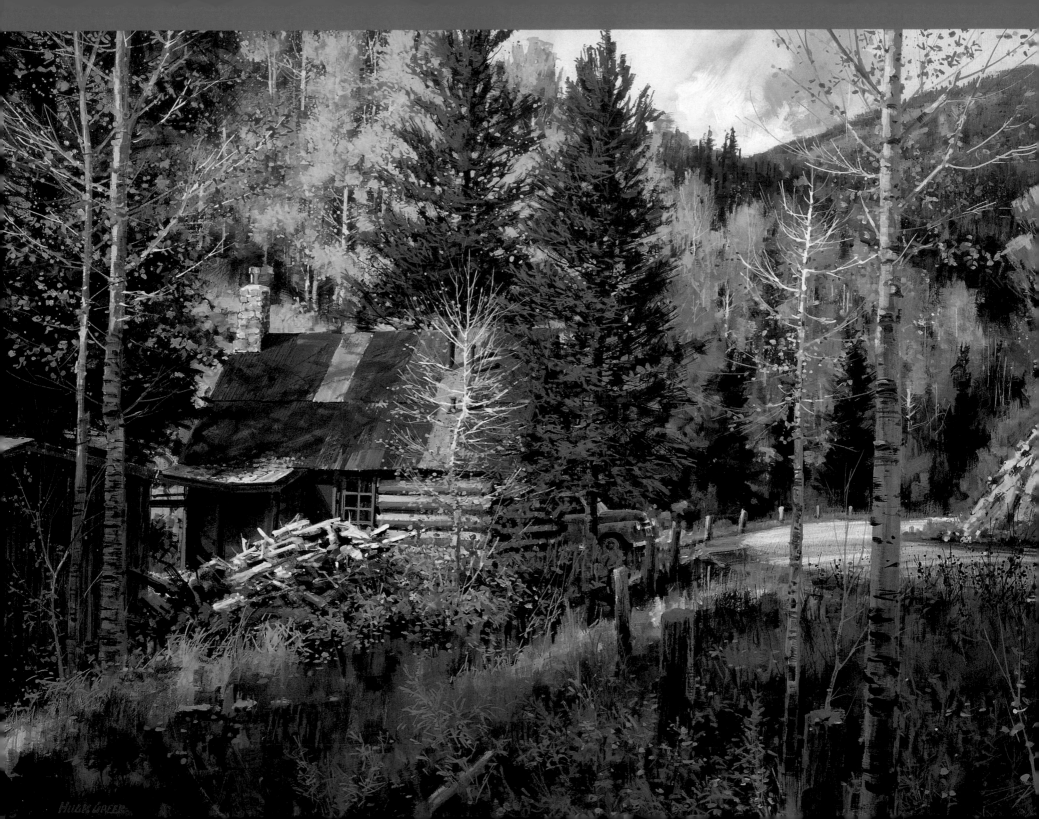

STEP-BY-STEP

Demonstrations

*I*n the following demonstrations we will see how to use acrylics to paint outdoors and how to paint in the studio from photographs. Irby Brown will show us how he uses acrylic paints as the underpainting for oils, and Iva Morris will show us how she uses acrylic paints with pastels. We will also see how to correct paintings we aren't pleased with.

Colorful Cabin

On a beautiful October morning, my friend and I were looking for a spectacular scene to paint (everything is spectacular in October). We spotted this cabin by the side of the road nestled in golden aspens and pines. After obtaining permission to set up in the owner's yard, we were delighted to find out he is a genuine published mystery writer! He even presented us each with a gift of his latest book—autographed and all.

Writer's Retreat
Acrylic on Gessoed Masonite
18" x 24" (46cm x 61cm)

Painting Outdoors

If you've never been to Santa Fe, New Mexico, you just have to go. It is approximately six-thousand feet above sea level in a high desert, and nearly everywhere you look you see a gorgeous scene with deep green foliage and vibrantly colored wildflowers. Just about everything makes a good painting in Santa Fe; my wife says that it's the only place she knows of where color combinations are pleasing throughout the entire year.

I never thought I'd be crazy about mud houses, but some of the adobe dwellings are really neat. Chances are good the adobe structures you see in this demonstration were made from the very ground on which they now stand.

Reference Photograph
I chose this scene because of the great depth. In addition to having the requisite adobe houses and colorful flowers, off in the distance are some mountains about twenty to thirty miles away.

STEP *1* | *Look Through the Clear
Plastic Window*

If you haven't already done so, make a clear plastic window as described in chapter one. Use a marker that will draw on plastic or glass to determine the proportions of your painting on the plastic window, in this case 9" x 12" (23cm x 30cm). This is a good size to use when painting outdoors, and it can be enlarged to 18" x 24" (46cm x 61cm) if the results are promising. Look through the window and survey your subject until you find the right composition.

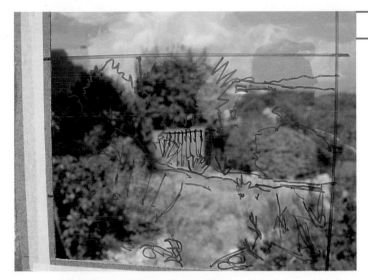

STEP 2 | Create a Sketch

As you sketch, constantly check to make sure everything is lined up. With a little practice you will get quite good at this, and you will have a very accurate sketch because you are drawing exactly what you see.

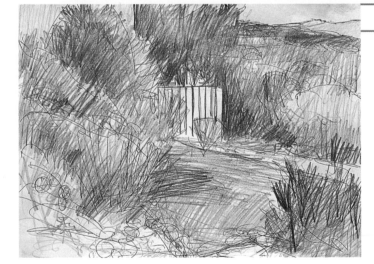

STEP 3 | Make a Value Sketch

Place a lightweight piece of bond paper over the plastic window sketch. Clean up the sketch and add some detail. Find the darkest darks first and work from there. Try to keep them close to the center of interest because that's where you want the highest contrast. The sketching process for the artist is like warming up for an athlete; it gives you time to think about how to approach the painting, and it can give you a better feel for the subject matter.

STEP 4 | Trace the Sketch Onto Gessoed Masonite

Use a pastel to totally cover the back of the sketch, then wipe it down to get rid of the excess pastel dust. Trace it off onto the Gessoed Masonite using a ballpoint pen. The ballpoint pen is a good choice because of the consistency of the line work.

REFER TO YOUR SKETCH

Keep your preliminary sketch because you may want to re-register your sketch onto the panel. You will cover up some of the line work as you paint, and you may want to find it again.

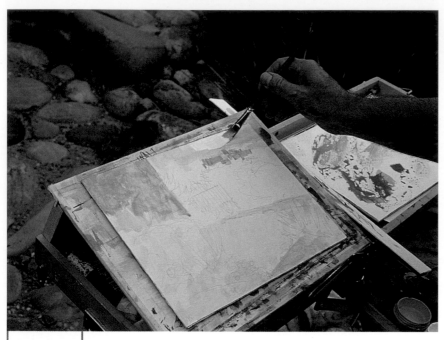

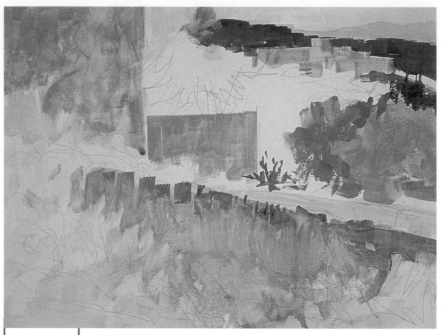

STEP *5* | *Paint the Distant Mountains and the Sky*

Use the same color in the far mountains as in the foreground, leaning toward the Cerulean Blue and white. Adjust it and paint the sky with a thin wash of pure white, painting the negative space. Continue looking for very similar colors so you can use them throughout the painting to tie it together.

Mix an adobe color using Quinacridone Magenta, Diarylide Yellow, Cerulean Blue and Titanium White. The mixture should lean toward the red and yellow with plenty of white. Lay in the color for the adobe dwellings. Find other adobe-like colors in the painting.

Next, mix a color for the cobblestones. Use the same mixture as the one for the adobe except add a little more Cerulean Blue and lots of white. Use some of this color for the grass in the foreground. Find other very warm light grays throughout the painting and develop them with thin washes.

STEP *6* | *Lay in the Greens*

Mix a dark green using Anthraquinone Blue with a touch of Diarylide Yellow and Quinacridone Magenta. Use this dark green, Jenkins Green and a little white to lay in the background trees. Mix a grayed green for the grass and apply it, letting some of the adobe color show through in spots. A lot of the fence color is in the grass. The fence color is made with all of the colors in the base palette, leaning toward yellow and white.

USING WASHES

If the adobe house in the far background is a little too strong, put a very thin wash of white over it to knock it back. Adding a thin wash of white to the background will cool it and obscure the details.

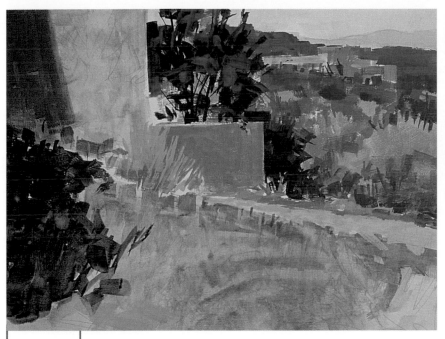

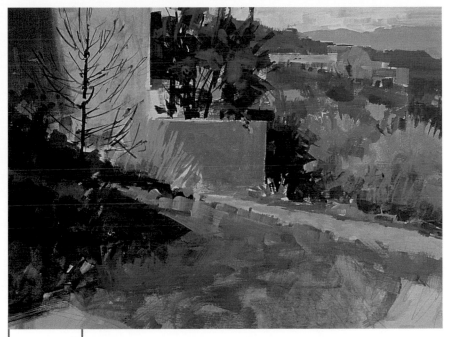

STEP 7 | *Develop Fence, Grass and Trees*

Use a bit of this fence color while it is still wet and scumble it into the grayed green you mixed for the grass. Again, this keeps the painting united with color.

Put in the tree trunks with the mixture of very dark green. Use the same dark green Mixed with a little Jenkins Green to develop the tree behind the fence. Develop the mulch under the hedge along the cobblestone path, and add a shadow to the adobe house. Continue to develop the cobblestone path.

STEP 8 | *Add Roses and a Small Pine Tree*

Using a ⅛-inch (3mm) to ¼-inch (6mm) one-stroke, begin blocking in solid areas of color that you will later develop with a smaller brush. Add roses and work with the grass colors. Further delineate the mountains from the sky.

Paint the skeleton of the pine tree that is in front of the adobe with the same dark green color you used earlier. This dark green can vary from a warm green to a cool green. As a general rule, the closer trees are darker and warmer.

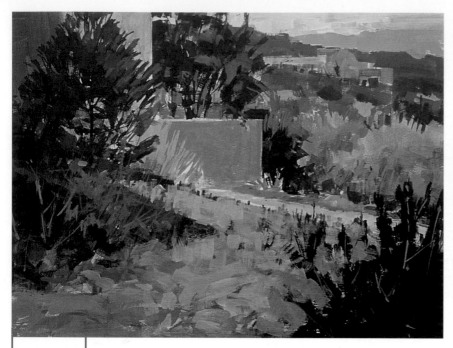

STEP 9 | *Paint the Pine Tree, Foreground Bush and Blue Spirea*

Develop the small pine tree with dark green. Remember that the shadow is only cast on part of it. Using the same dark green, begin working on the foreground bushes. Add the blue-purple flower (blue spirea) and develop more of the cobblestone walk.

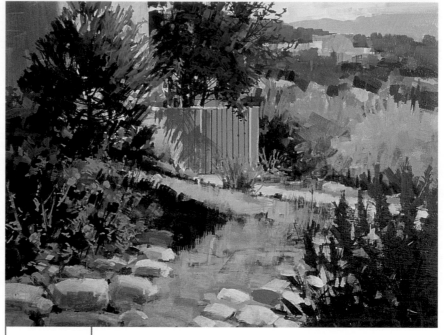

STEP 10 | *Detail Work*

Pull things together with some detail work using a ruling pen, particularly on the foliage, flowers and the joints in the fence. The ruling pen lays down a heavy bead of opaque paint.

PAINT ON THE CORRECT GROUND COLOR

When painting midday scenes, paint on a white board. In late evening or early morning, try an undercoating of a colored wash (usually a pale orange or pale red).

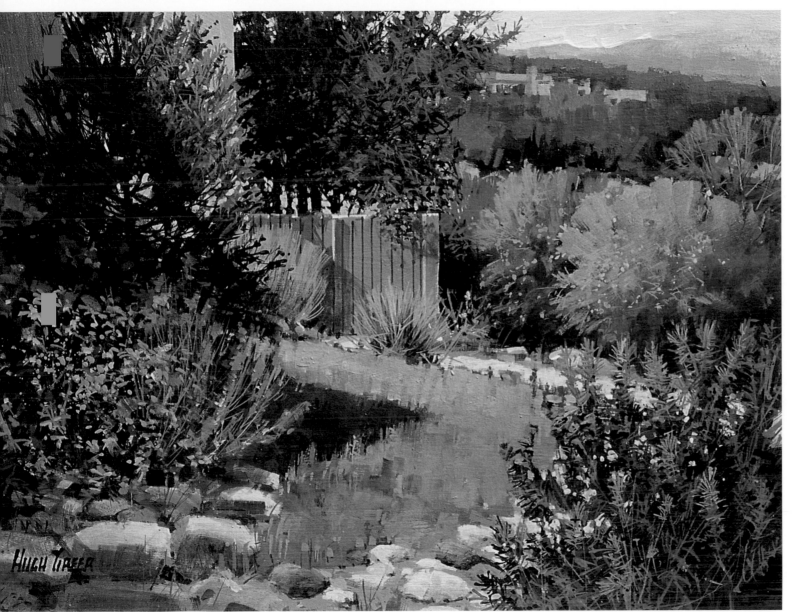

Final

Besides adding the flowering Indian Paint Brush, in the grass with one of the small brushes continue working on the foliage and flowers with the ruling pen and nos. 0–2 script brushes.

Light From the North
Acrylic on Gessoed Masonite
9" x 12" (23cm x 30cm)

Painting Indoors From a Photograph

The subject of this demonstration is an old chapel that caught my eye in Rowe, New Mexico. I've learned to carry a camera whenever I travel so I can take photos of a scene that strikes my imagination. I took several photographs of the chapel for future reference, knowing that just one would not provide sufficient information. By the time the film was developed, I needed all the help I could get to refresh my memory.

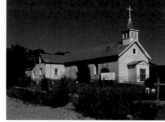

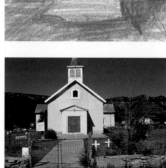

STEP 1 | Create a Sketch

With photos in front of you, make some thumbnail sketches of your subject. This will help you decide on the view you like best and will also start your creative juices flowing. After choosing your favorite, enlarge and clean up your sketch.

Reference Photographs

Take several photographs from different angles and directions for a better understanding of the subject matter. When you begin your project, you will be glad you took the time to do this, because seeing the scene from different vantage points helps invoke the thoughts and ideas you had when you originally surveyed the scene.

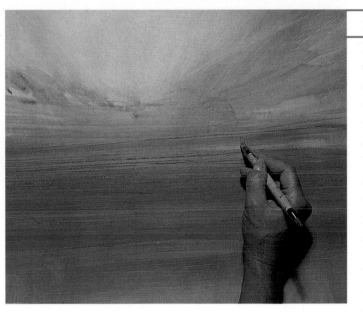

STEP 2 | *Experiment With Lighting*

For an added challenge, create different lighting situations. The sunset helps create an appropriately somber mood for the scene.

Wash a Gessoed Masonite panel with a mixture of Quinacridone Magenta, Diarylide Yellow and Titanium White. Apply it using a 1½-inch (38mm) one-stroke. While it is still wet, take a paper towel and literally stain the board. As you drag the paper towel through the wet paint, press just hard enough to leave streak marks.

STEP 3 | *Lay in the Sky*

Draw the line of the mountains in the background where the mountains meet the sky. Don't worry about getting the rest of the building traced off at this point. Wash the sky portion above the mountains with a mixture of Cerulean Blue and a little bit of Quinacridone Magenta with a touch of Diarylide Yellow to make a nice grayed purple. Mix this thin enough to let the color underneath show through the purple. It's okay to paint over the line of the mountains, as the sky color can be beneficial in defining the mountains.

Mist the board lightly with a light-spray bottle. Use a 1½-inch (38mm) one-stroke for a wash that is transparent. While this wash is still damp (work fast—this is not the time to answer the phone), use a damp brush that has all the excess water wiped out. Use a "push the brush" technique to lift out areas of paint to shape the cloud. Be very gentle, like you're giving a butterfly a back massage. Be as light and careful as you possibly can; otherwise, you might lift out a big hunk of paint, creating an unattractive sky. The lift-off tool is also a good instrument for lifting off paint. Let this first very thin transparent wash of grayed purple dry and apply a second coat to the lower part of the sky.

ALLOW PAINT TO DRY

If you start the second coat of paint before the first coat is dry, you will lift up part of the first coat and have to start all over—you will never be able to patch the hole. If this happens, start from scratch by whiting out everything.

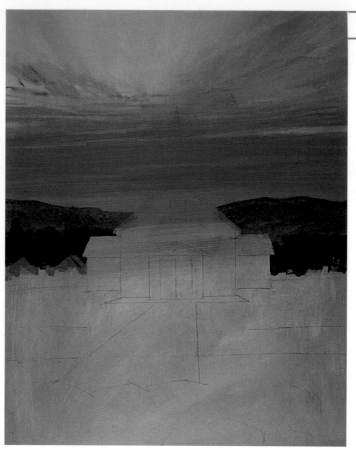

STEP 4 | Transfer the Sketch

Trace the sketch onto the support using Saral transfer paper or pastel on the back of your sketch.

STEP 5 | Lay in the Mountains and the Background Trees

Mix a little Anthraquinone Blue with some Cerulean Blue, plus a little orange (a mix of Diarylide Yellow and Quinacridone Magenta) and Titanium White. You want this blue to be a mid-range dark color. Paint the background mountains and let some of the base color show through to help unify the painting. Use the lift-out tool to remove areas of dark blue to let the color underneath come through.

Paint in the background trees with a 1½-inch (38mm) one-stroke; this is the darkest dark in this painting. The background trees are going to be made with a mixture of Anthraquinone Blue and Diarylide Yellow with a small amount of Quinacridone Magenta. This should be a very dark blue-green with just a touch of white.

While the trees are still wet (tacky), spray the tops of the trees with the light-spray bottle to soften those edges a little bit. Some finger painting to soften edges where the trees meet the background mountains might be appropriate.

STEP 6 | *Lay in the Adobe Color*

Paint the adobe color, using a combination of Diarylide Yellow, Cerulean Blue, Quinacridone Magenta and Titanium White (the majority of the mix should be white). Next to the sky, this is the lightest color in the painting. It is very easy to paint over the dark colors in the background with this opaque mixture.

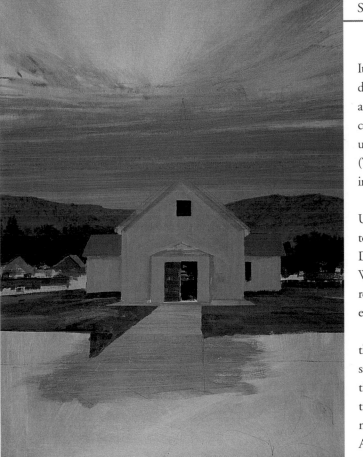

STEP 7 | *Develop the Chapel and the Grass*

It's okay if your first coat is too dark just cover the adobe with a lighter color letting the darker color be part of the shadowing under the eaves of the chapel. (This is called turning a mistake into a success.)

The bright red roof is metal. Use Quinacridone Magenta, a touch of Anthraquinone Blue, Diarylide Yellow and Titanium White to achieve a soft grayed red appropriate for this time of evening.

When mixing the dark for the windows and door, use the same dark (with a slight variation) used for the background trees. To achieve this variation, mix Quinacridone Magenta and Anthraquinone Blue for a dark purple, then start adding small amounts of Diarylide Yellow until a dark, almost black is fashioned. There is no Cerulean Blue in this mixture.

The grayed green for the grass is a combination of Cerulean Blue and Diarylide Yellow. The source of light in this picture is coming from the reflected sky.

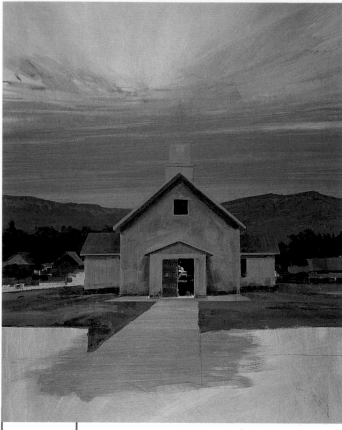

Stone walls can be established in a few ways:

→ Lay down the stone color, modeling the color as you go with slight variations in value. Let this dry and then put down a very dark wash over the stones. Work quickly, and while this is wet, use the lift-out tool to shape the stones, leaving the dark ridges between the stones.

→ Use a fine brush, no. 1 or 2, and with a dark color, paint the joints over the light stone color.

→ Or do both!

STEP 8 | *Add the Steeple and Other Details*

Create the shadows underneath the eaves using the hard edge/soft edge technique. If the steeple and sky are too close in value, either darken or lighten the steeple. Until you get all the color on the board, it's hard to know how things are balancing out and what direction to take.

STEP 9 | *Create the Stone Wall*

Paint a warm light gray using a combination of mostly Titanium White with Anthraquinone Blue (a very small amount), Quinacridone Magenta and Diarylide Yellow. The front of the stone wall is a dark mix of Anthraquinone Blue, Quinacridone Magenta and Diarylide Yellow. Paint this combination over the top of the lighter color to suggest the stones. Use the lift-out tool to remove some of the paint to model the stones. Allow some of the dark underneath color to show through for the joints between the stones. Paint additional joints at random using the no. 1 script brush. Put in the darks of the grass.

USE A LARGE BRUSH

Always remember to use that large brush— ½-inch (12mm) to 1½-inch (38mm)—as much as possible in the preliminary work.

DARKENING GRASS

If the grass appears to be too light, apply a dark blue-green transparent wash over it.

| STEP *10* | *Develop the Foreground Dirt and the Chamisa Bush* |

Apply a dirt color in front of the chapel with a ¾-inch (19mm) one-stroke. The dirt color is going to lean toward red. It's a mix of mostly Diarylide Yellow and Quinacridone Magenta with some Anthraquinone Blue, Cerulean Blue and Titanium White.

Use the base colors for the chamisa bush, but lean toward Cerulean Blue with a touch of Quinacridone Magenta to gray it. Try to keep the chamisa bush from jumping off the painting. The difference in value between the foreground dirt, grass and chamisa bush should be slight and barely noticeable.

| STEP *11* | *Do Some Finger Painting* |

Use the spray bottle while working the lower portion of the painting to keep it wet for easier blending. Lighten some of the grassy areas. Do a little finger painting in this area while it is still wet. Soften the edges that are on the perimeter of the painting keeping the hard, crisp edges closer to the center of interest.

STEP *12* *Add Trees, Headstones and Gate Posts*

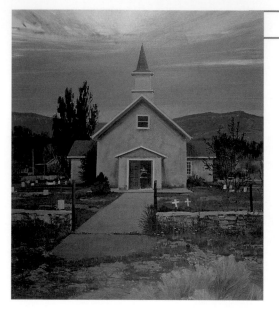

Use drafting or masking tape to protect the red roof from any tree color. Paint the poplar trees a very dark color using a mix of Anthraquinone Blue with a touch of Quinacridone Magenta and Diarylide Yellow. This should be the darkest value in the painting. Use the flat edge of the ¼-inch (6mm) or ½-inch (12mm) one-stroke to paint the silhouette of the tree. Add more Diarylide Yellow and Titanium White to the mixture to highlight and shape the trees. This is still a dark value.

Lay in the gate posts with a ⅛-inch (3mm) one-stroke. Use the same dark color (with the same value range) that you used for the poplar trees. Add a touch of Titanium White to this mixture to highlight the posts.

The headstones are a mix of mostly Titanium White, with a touch of Cerulean Blue, Diarylide Yellow and Quinacridone Magenta, making a gray that can be either warm or cool. The closer the headstones are to the viewer, the lighter and brighter they will appear. As they recede into the background, they will become more of the gray color.

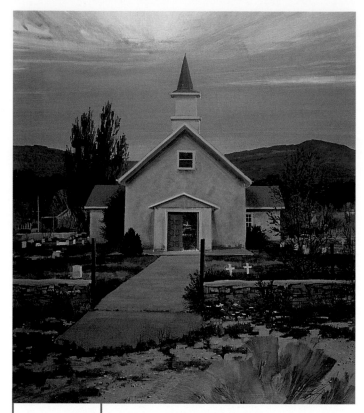

STEP *13* *Balance the Painting*

This is the time to bring things into balance. Darken or lighten the mountains as needed. Define the areas showing through the trees behind the chapel—you are painting the negative space. Darken the grass in front of the chapel. Rework the foreground in front of the stone fence where there's dirt and grass to make it a little bit more lively. Do a little finger painting in the foreground to soften edges, but don't add as much detail that it detracts from the center of interest. Use a dark blue-green glaze over the chamisa bush at the bottom of the painting. Add some dark blue glazing in the background. Add details to the steeple.

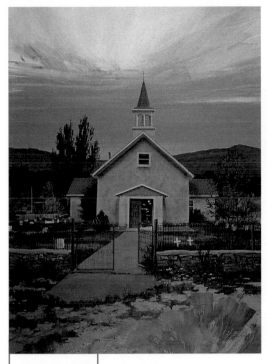

| STEP *14* | *Add Fence* |

The last thing to paint is the wire fence and gate.

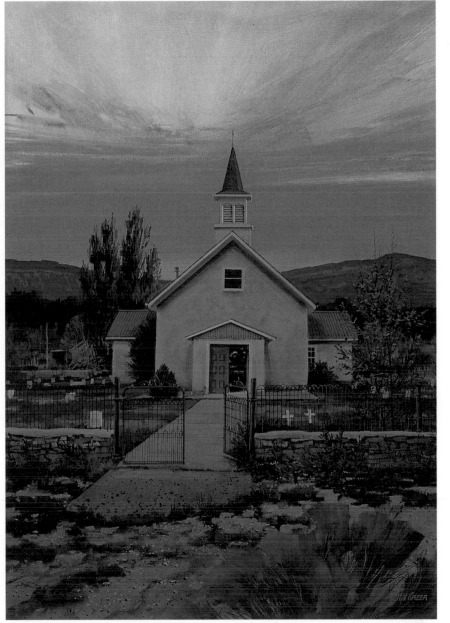

Final

The only light in this painting is reflected from the setting sun in the evening sky. Altering the lighting can profoundly affect the mood of the painting, as witnessed in the comparison between the photographs in the beginning of this demonstration and the finished painting.

Evening Prayers
Acrylic on Gessoed Masonite
24" x 18" (61cm x 46cm)

Acrylic Underpainting for Oils

Irby Brown
SANTA FE, NEW MEXICO

Irby Brown is a nationally recognized oil painter who often uses scenes from California and the southwestern United States as the subjects for his paintings. When asked what makes him stop his car and unload the easel and paints, he said, "I follow the whims of the land and the skies and stop when something catches my eye: light on a chamisa, water moving through an arroyo, a bend in a dirt lane leading straight into a gathering of storm clouds just above a mesa."

He calls himself a realistic impressionist, but he's also kin to the romantics. Passion, therefore, is central to his work. This passion is evident in the vigorous and lush brushwork used to create the delicate yet vivid vignettes for which he is noted. He says his faith in God is a large part of his success and talent, but that creative inspiration isn't always so easy. "Some days are just naturally creative times. Other days, you just don't feel that creative flow. But I've found that when you make yourself paint, the process of creating that painting can stimulate inspiration as you lose yourself in the colors, forms and textures."

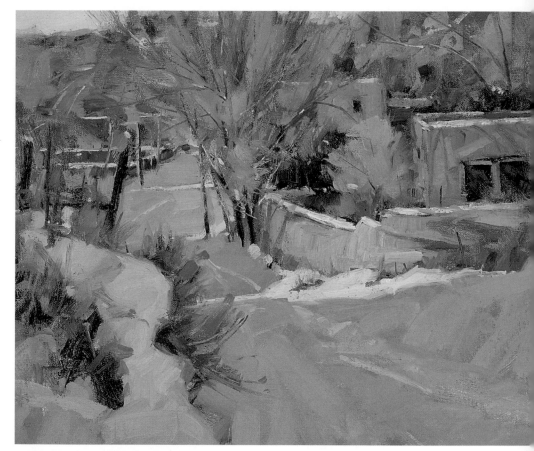

Why Underpaint With Acrylics
Some oil painters like to underpaint, as Irby does, but the drying time is often long if the humidity is high. A time-saving solution is to underpaint with acrylics, a fast-drying, water-based medium.

Drifted Byways
Irby Brown
Oil over acrylic
16" x 20" (41cm x 51cm)

Irby's Easel and Palette

The oil paint colors rest along
the perimeter of the palette; the
acrylics are on the inside.

Oil Painter Irby Brown

Irby is comfortable painting any-
where, indoors or out, though his
real passion is the outdoors.

Photography by Ed Pointer

STEP *1* *Prepare the Support*

Cover the Masonite with linen canvas. Use white glue or Golden Soft Gel to secure
the canvas to the Masonite. Give the canvas two thick coats of gesso, allowing each
coat to dry thoroughly. Mix Red Oxide with just a touch of Ultramarine Blue to cre-
ate a tan color. Apply this as a thin wash over the dried gesso to give the support an
undertone. Sketch the subject directly onto the tan board with a soft pencil.

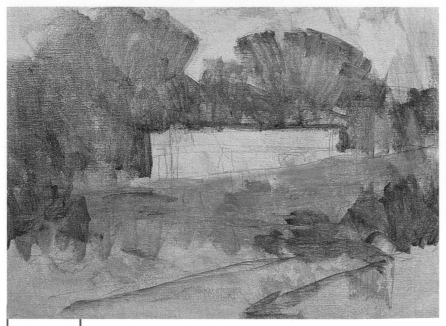

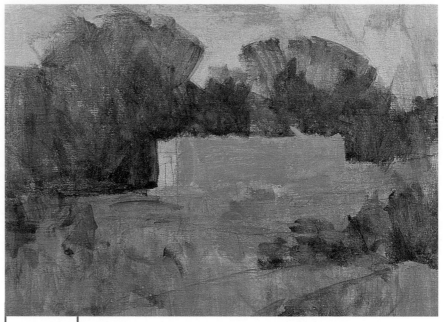

STEP **2** | *Begin Laying in Color*

Mix Red Oxide, Titanium White and touches of Ultramarine Blue and Quinacridone Magenta. Apply this warm, reddish color to the ground in front of the chapel and to the trees in the background. The lightest value on the canvas is the sky. You are going to let this color peek through subsequent color applications to enhance the color harmony of the painting.

STEP **3** | *Add the Chapel and the Dark Values*

You need to make the chapel appear white while making its value darker than the foreground. To do this, mix a medium gray-blue (no. 3 on the five-point scale) and add pale orange, its complement. Paint the chapel.

Strengthen the darks with Ultramarine Blue, Quinacridone Magenta and Red Oxide. Use this color to darken shadowed areas of the trees and bushes.

ACRYLICS DRY QUICKLY

The advantage of acrylic under oil paint is that color and composition adjustments can be made quickly because you only have to wait a few minutes for the acrylic paint to dry before applying additional color on top of it.

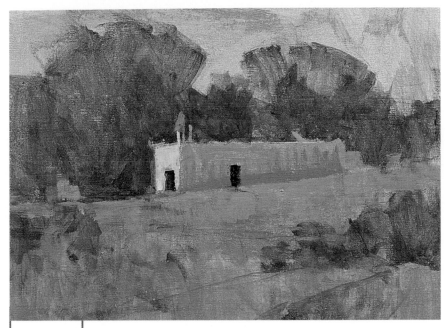

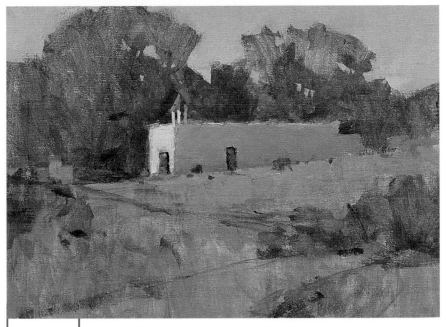

STEP *4* | *Continue Defining the Chapel*

Add the building at the rear of the chapel to add interest and help break up the space.

Add some subtleties of color to the chapel; cool at the ground line and warmer as you paint up the wall. Add a touch of Cadmium Yellow Medium with the gray you mixed in step one to give a warm spot of reflected light on the chapel. The doors and windows will be the darkest spots in the painting. Paint in the steeple with Quinacridone Magenta and Titanium White.

STEP *5* | *Paint the Negative Space and Enhance the Center of Interest*

Paint the negative space around the trees and punch holes in the sky. Further define the center of interest by using the palette knife to put in the top edge of the chapel with bright white (Titanium White and a dab of Cadmium Yellow). Soften the edges between trees and roof by blending with a dry brush. Place small forms at the base of the chapel to break up the straight line; these shapes will later become bushes or worn spots on the adobe.

BALANCE

> Create a balance of shapes and colors that is pleasing to you. Remember that colors get their character from the hues that surround them; therefore the same color may register differently in various places in your painting.

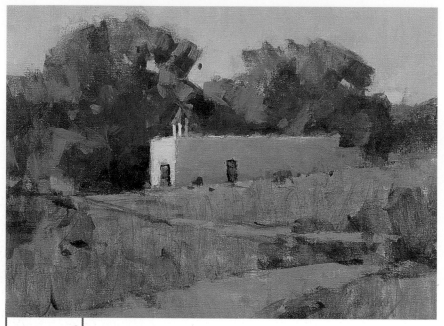

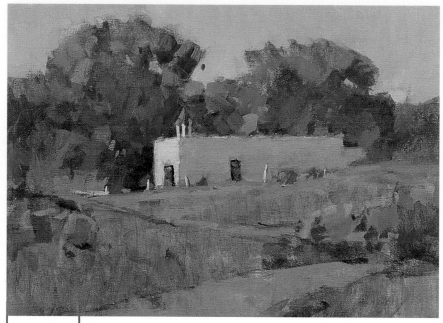

STEP 6 | *Work the Background Trees, Sky and the Foreground Road*

Wash a warm orange into the sky; there is little wait for drying time with acrylics. Create dark passages into trees using Ultramarine Blue, Quinacridone Magenta and Red Oxide. Begin developing the foreground dirt road by using Red Oxide, Ultramarine Blue, a touch of Hansa Yellow Light and lots of Titanium White.

STEP 7 | *Begin Using Oil Paint*

Use thin passages of oil paint over the acrylic. Mix a pale green to complement the orange trees, then lay in the small bushes. Add some of this pale green to the trees until you achieve the right balance.

Mix a tan color and paint in the road, creating the classic "Z" composition found throughout art history. Add the fence posts around the chapel.

TIPS ON IRBY'S TECHNIQUES

- → To this point, Irby's technique with acrylics looks just like an oil painting. Irby does a lot of "scumbling" (working the brush in all different directions).
- → Ultramarine Blue and Red Oxide make a really simple black.
- → Highlights and soft edges are advantages of oil paint, but as you have seen, these effects can also be achieved with acrylics.
- → Utilize as much of the underpainting as you want by allowing acrylic color to show through the oil paint.

STEP 8 | *Add Some Finishing Touches*

Use the same pale green from step seven and apply it to the fore-ground and midground. Let some of the acrylic underpainting show through. Add a warm pale pink to the sky toward the horizon. Leave a highlight on the top edge of the chapel. Add a hot red-orange to the bell tower roof. Paint the negative space around the bushes.

RECYCLING PAINT

When Irby is finished with his oil palette, he mixes it all together with a palette knife and puts it into an empty tube for later use. It makes a great gray color.

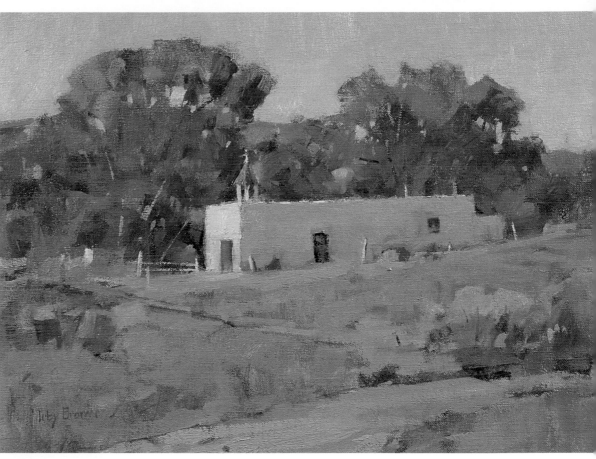

Final

Add a window to the chapel with blue-green and define some tree limbs with the tiny corner of your brush. Use an off-white color (ninety-five percent Titanium White mixed with five percent of the orange) for the tree limbs. Paint the darker limbs with a mixture of Ultramarine Blue and Red Oxide. Take a close look at Irby's brushwork; this is why he is a master of what I call, "controlled vagueness."

La Cienegia, Autumn
Irby Brown
Oil over acrylic on Masonite
12" x 16" (30cm x 41cm)

Acrylic Under Pastels

Iva Morris
LAS NUTRIAS, NEW MEXICO

The pastel landscapes of Iva Morris celebrate the everyday beauty that surrounds us. "Knowing a place well is so important when you are painting a site-specific landscape. You must know how the shadows and light will look at any time of the day," says Morris. "And knowing it well also conveys the heart of the place to the viewer."

The resulting Morris landscapes capture that sense through a generous application of pastels that achieves an almost sculptural quality. Her rich palette, suffused with light, explores a wide range of subtle tones.

Iva's printmaking background influences her art. She works in layers in a method she created herself. She uses Wallis paper, which has a finish like fine sandpaper. She mounts it to Gator board using either white glue or Golden Soft Gel to keep the surface flat. After mounting the Wallis paper on Gator board, Iva covers the Wallis paper with pastels. Wallis paper has lots of tooth and works nicely with pastels.

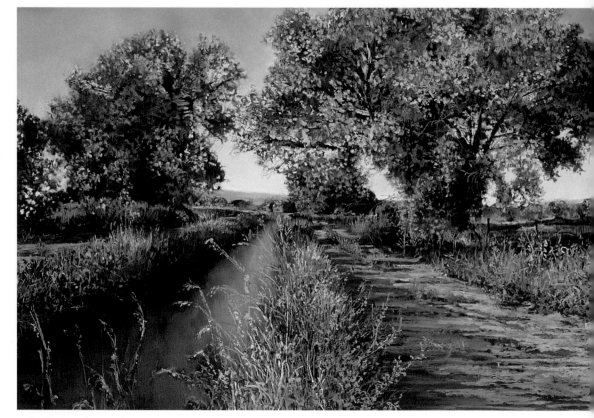

Autumn Acequia
Iva Morris
Pastel
24" x 35" (61cm x 89cm)

Pastel Artist Iva Morris

When working outside, Iva completes field studies, takes photographs and finishes small paintings. Pastels are perfect for this because they're so fast, which is especially important when working outdoors.

Photography by Mary Elkins

STEP *1* | *Prepare Your Paper*

Mount the Wallis paper to a piece of Gator board using either white glue or Golden Soft Gel to keep the surface flat. Cover the paper with a brownish red pastel using a color in a middle-scale value (no. 2 on your five-point value scale).

STEP *2* | *Create an Undercoat*

Make a mixture of approximately seventy percent water and thirty percent Soft Gel. Use an inexpensive foam brush to apply the mix smoothly. Don't use your good brushes as they will quickly wear out on the abrasive surface of the Wallis paper. Allow the coating to dry, creating an undercoat.

STEP 3 | Sketch

Make a sketch that you will transfer onto the Wallis paper. This was sketched from photographs taken on location.

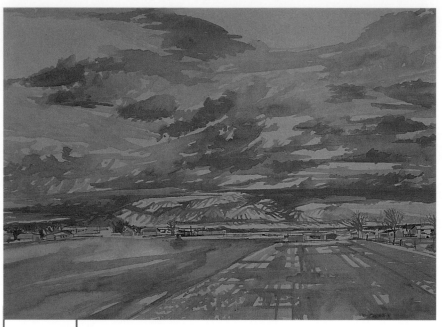

STEP 4 | Transfer the Sketch

Transfer the sketch onto your newly toned Wallis paper. Make a one-tone underpainting with a mixture of Ultramarine Blue, Pyrrole Red and a touch of Hansa Yellow Medium. Use this thin wash (a warm, dark purple color) to set the values. This tonal wash varies between nos. 2–4 on the five-point value scale. You should be able to work your pastels in both lighter and darker values.

STEP *5* | *Turn Things Upside Down*

Working upside down helps keep unwanted pastel dust from falling into the fore-ground. Use a sky blue pastel and start layering in the sky. You can also incorporate pale yellow and blue-gray and blend as you proceed. Bring in pink and orange or any other colors you want in your sunset.

STEP *6* | *Blend the Pastels*

Blend the sky with the side of your hand and constantly wipe your hand to keep the colors pure and bright.

USING AN AIR COMPRESSOR

Iva will often go back in with an air compressor to erase the pastels with pressurized air. The pressurized air will literally blow away any unwanted pastel areas. She could also use a little water on a brush to lift out unwanted areas of pastel.

Original acrylic undercoat

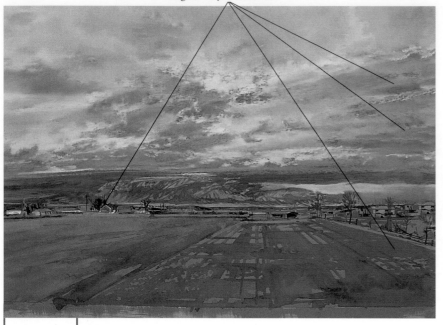

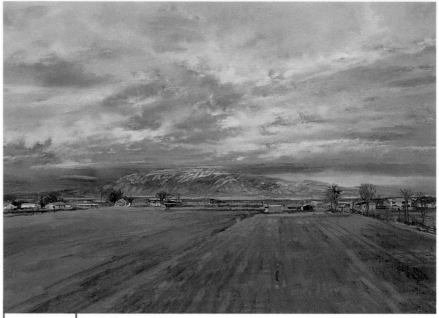

STEP 7 | *Create Harmony*

Turn the painting top side up. Continue to develop the painting with pastels, allowing some of the original acrylic undercoat to show through to unify the painting.

STEP 8 | *Layer the Pastels*

As you cover the support with pastels, use water and a small amount of Golden Soft Gel (ten percent) to manipulate, smooth and blend the color in the foreground. Use whatever brushes you are comfortable with. The wetness of this process buckles the paper unless it is mounted onto a rigid support. These mixtures must be thoroughly dry before proceeding to the next step. The water and Soft Gel mixture are only used in the foreground, not in the sky. Notice how the line work of the mowed grass in the foreground leads your eye toward the center of interest.

Final

Add detail to trees, houses and the foreground fence. The acrylic underpainting still peers through the pastel in spots, helping to unify this piece and contribute to the somber quiescence of the sunset moving toward darkness.

Las Manzanas
Iva Morris
Pastel and acrylic on Wallis paper
18" x 24" (46cm x 61cm)

Saving a Bummer of a Painting

Let me give you my definition of a *bummer* of a painting: A painting that nobody likes except you, the artist, and after a while when you find out nobody else likes it, you decide you don't either! At first your friends won't tell you that the painting has a problem, and even if they do, you don't want to hear it. That's why artists are called sensitive.

If you have a painting like this, set your piece in front of you while you're doing other work. You may be surprised at what you eventually see. As you're working on another piece, some technique, principle or even a new idea may suddenly dawn on you. It may work so well on that *bummer*, you'll want to give it a new name.

Painting Number One

This piece, originally titled *Kiamishi Hikers*, had been around for a year or two and hadn't sold. It faced the wall for another year. I still liked it, but it was stale and the fact that nobody wanted it made me like it less. So I propped it on my work surface where I could easily glance at it. The sky, mist and background mountains were pleasing to me, so I decided to leave them as they were. After a while, I determined the problem to be in the midground and foreground areas.

Use Composition to Move the Viewer's Eye Around the Painting

Once I decided to leave the background as is, I focused my attention on the smooth and uninterrupted line of the midground dark hill. So much of the line composition leads the eye to the left and out of the picture! Not even the dark foreground tree can stop this movement. The eye should be directed to see more and more of the painting, not the wall next to the painting.

I decided to change everything below the line created by the midground dark hill. The line of this hill is too smooth. The figures are poorly spaced. The barn roof adds nothing to the composition and is out of scale.

Soften the Hill Line and the Foreground

Since the area is rich in redbud trees and pines, I thought I would break up the smooth line of the background hills with some irregular pines and the sporadic placement of redbuds. The placement of the redbuds momentarily arrests eye movement and focuses the viewer's eye onto the figures. I used a low chroma for the redbud color.

I painted over the foreground to simplify it and eliminate the barn roof, and painted over two of the four figures.

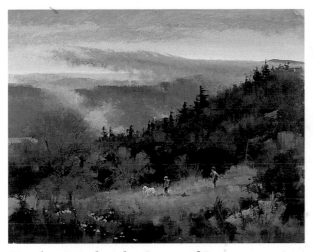

Further Develop the Center of Interest

I used a lift-out tool in the wet paint of the hill-line trees for some texture on the hill and to allow some of the old painting to come through. I added the dog to make a threesome. I painted the wildflowers using a no.1 script brush. The redbud in the foreground is blocked in with a ½-inch (12mm) one-stroke.

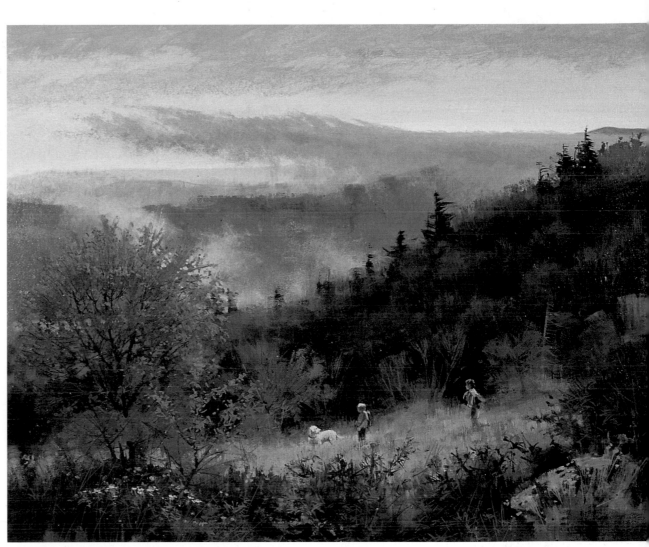

Finished Painting

I added detail to the redbud in the foreground by masking and then splattering to suggest individual buds. I used a ruling pen for some of the limbs and leaves. I gave the right side of the redbud in the foreground more detail to keep the eye closer to the center of interest. The figures and the dog needed to be more focused, so I added highlights using a ⅛-inch (3mm) one-stroke and no. 1 script brush. Now the "Ahhh and Ooooh" meter of my friends has come to life and has inspired me to come up with a new name: *Buds*—that says it all.

Buds
Acrylic on Crescent
Illustration board no. 1
14" x 18" (36cm x
46cm)

Painting Number Two

When you are old enough to have grandchildren and they move away to Michigan, Michigan quickly becomes a favorite place to visit. An interesting thing about the state is the sight of neat tidy farms sporting much-needed snow fencing. It was this snow fencing that helped save another *bummer* of a painting.

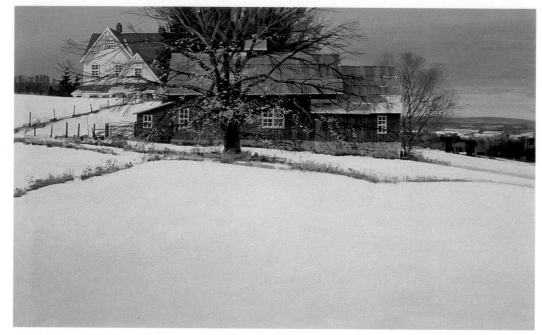

Determine the Problem

This painting, *The Fallen Guard*, did not go through the usual elimination process to qualify as a *bummer*—it hadn't even been to a gallery. It was my intention to leave a lot of white foreground in the finished painting, but it was just not working. Not only did my friends not like it, I really wasn't satisfied with it either. It just didn't have the right balance. There was too much snowy foreground to make a strong, interesting composition.

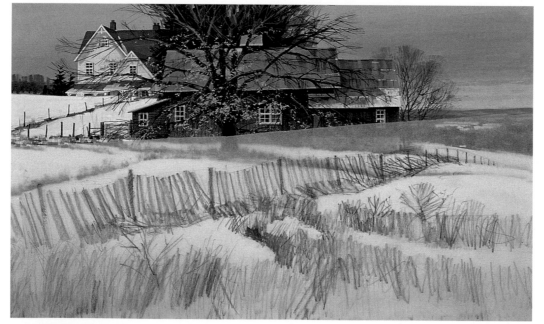

Add Interest to the Foreground

By placing a piece of tracing paper over the foreground, you can sketch a possible solution to the problem and make any adjustments to your composition very easily at this point. The tracing paper is transparent enough for you to see the entire painting and how your new sketch works.

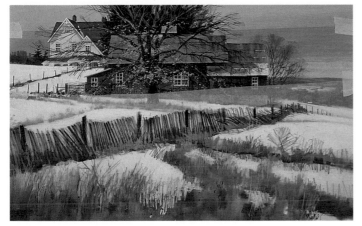

Try Out the New Composition

Place a clean sheet of thin, clear plastic film over the sketch and tape it to your painting. Begin to paint directly on the acetate. There will be two layers over the painting: the sketch on tracing paper, and over that, the acetate to paint on. This process helps to establish shapes and color composition before painting directly on the original. Remove the pencil sketch and leave the painted plastic film for a clearer understanding of what you will have on your original. If you like what you see, trace the sketch off onto the original, and you're ready to begin painting.

TIPS FOR PAINTING GRASSES

- Make several sketches on tracing paper to see which one you like best.
- Use photos to refresh your memory of the grasses and fences in that location.
- To create negative space, scrape away excess color on the plastic film with a toothpick or a small, sharpened wooden stick. Keep in mind that the longer you wait to remove acrylic on clear plastic film, the harder it will be. If the acrylic dries too much to make scraping feasible, dampen the acrylic paint surface.

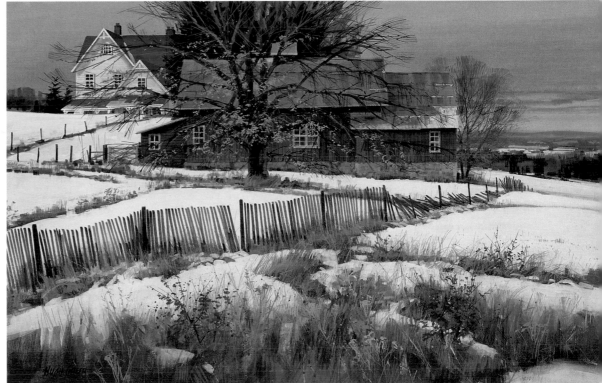

Finished Painting

The overcast day called for a little more gray in the grass color than was on the plastic film overlay. You may find it necessary to adjust your colors slightly to fit the overall color scheme of your painting. Paint in the snowy ground around the dead grass. Use splatters and a lift-out tool to create the dead grass textures.

The Fallen Guard
Acrylic on Gessoed Masonite
14" x 22" (36cm x 56cm)

Painting Number Three

There is nothing like a blast of color from early daffodils after a cold February to get your attention! *Trumpeting Spring* celebrates the promise of more color and warmer weather in the coming months. Even though I liked a lot about this painting, I knew something was missing when I was about halfway finished with it.

Determine the Problem

I had painted all the flowers using transparent luminous glazes on gessoed Hardbord. The dark negative space painted behind the flowers defines their shapes, making them a brilliant center of interest. I felt a single lonely daffodil against the dark tree trunk would provide the additional interest needed to capture the viewer's attention.

White Out a Space on the Tree

The surface of the painting needs to be white where the new daffodil will be in order to achieve the desired luminosity. Use several coats of Titanium White to get a bright white.

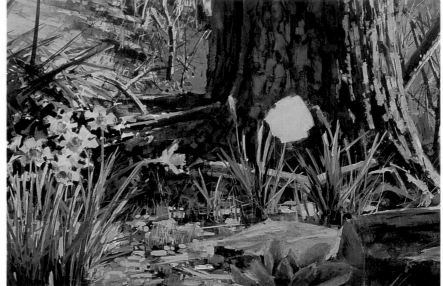

Add Luminescent Color

Paint over the bright white with Diarylide Yellow and a small amount of Soft Gel for a luminous bright yellow.

TIPS FOR EDITING PAINTINGS

- Paint a daffodil on a sheet of clear plastic film and move it around your painting to see where it belongs. If you like, you can experiment with several different postures for your daffodil as well.
- It is possible to save a whole painting by whiting out the undesirable parts of the original with Titanium White or gesso. Usually, if more than half the original painting has to be painted white, it's probably best to just start over.

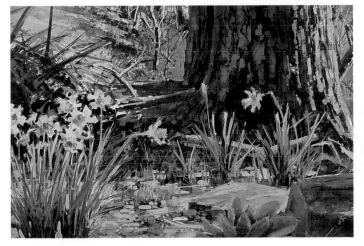

Paint the Negative Space

Determine the shape of the daffodil by painting the negative space around the flower. Because the tree trunk makes up the negative space, paint an opaque mixture of the base palette for the bark. To suggest moss on the bark, mix a warm blue using the base palette with a little extra Titanium White and Anthraquinone Blue.

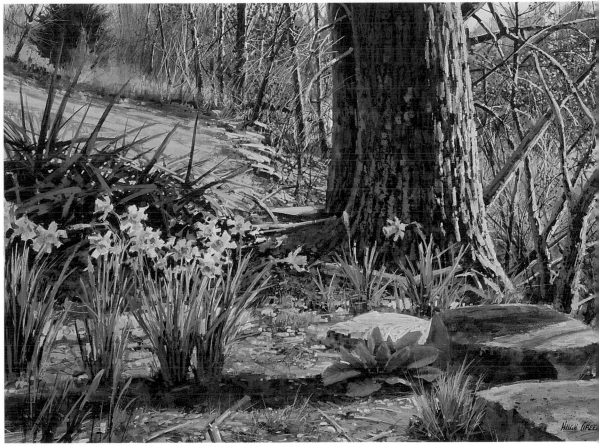

Finished Painting

Add splatters and limbs with a ruling pen and a no. 1 script brush to give the painting some finishing touches. The new flower's shape and suggested motion point back to the rest of the group, keeping the eye within the center of interest.

Trumpeting Spring
Acrylic on Gessoed Hardbord
18" x 24" (46cm x 61cm)

Conclusion and Gallery

While this book has focused on the how's, why's and versatility of acrylic painting, the development of your own signature style has been a recurring theme. Painting is much more gratifying once you achieve your personal style and technique. But even then, your work will continue to be refined as you develop new techniques and incorporate them in your work. Art is a dynamic process offering lifelong challenges and rewards.

As illustration to that point, I should say writing this book has been an enormously illuminating process for me. Author Graham Wallas wrote in 1914, "How can I know what I think till I see what I say?" This book has provided an opportunity for me to question myself, to articulate what I know and to reinforce the direction and goals for my work. Painting, like writing, forces the artist to examine constantly and grow.

I want to thank North Light Books for the opportunity to write this book. It has been an honor to work with them. I also wish to thank Golden Artist Colors Inc. and Ampersand Art Supply for providing invaluable technical information. They have assured me they will be happy to hear form you, so don't hesitate to contact them with questions (see the Buyer's Guide on page 124).

Now, go forth into the land and paint something, or at least find a good place to go fishing.

TIPS ON LEARNING

→ Learn from fellow artists. Many are eager to share secrets and tips. Form small informal groups and meet at one another's homes and studios to share ideas and critiques each other's work.

→ Include spouses, as their opinions and instincts are valid and valuable regardless of their background in art. The opinions of your husband or wife will often parallel the opinion of the general public.

→ The art that you struggle with can be your best teacher.

→ Look at yourself as the only student in art school. You are also the best teacher you will ever have.

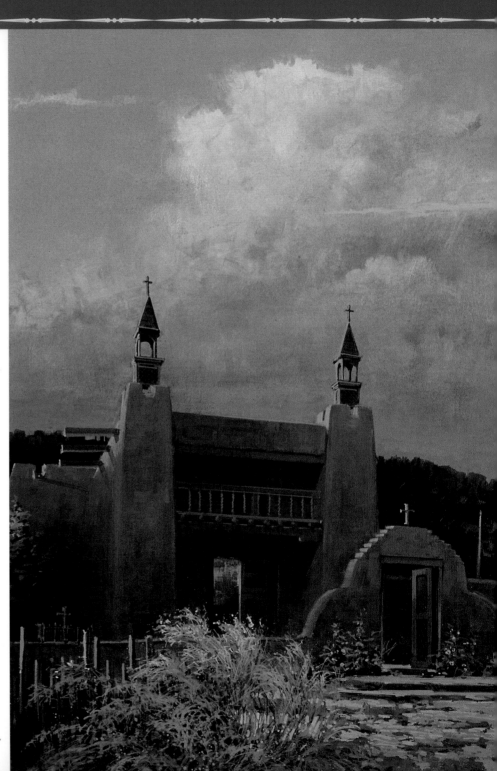

Evening Mass
Acrylic on Gessoed Hardbord
16" x 12" (41cm x 30cm)

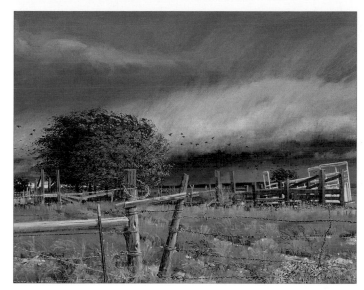

The life of a professional painter is a challenging one. I wish you all the rewards and gratification that I have enjoyed in my artistic career. Paint with passion. Develop your talent. Paint as though your financial life depends on it, and maybe...your financial life can depend on it.

Sumac at Willoughby Springs
Acrylic on Crescent Illustration board no. 1
11" x 16" (28cm x 41cm)

Storm Over the Prairie
Acrylic on Gessoed Hardbord
18" x 24" (46cm x 61cm)
Reference to *Cattle Chutes*, page 77

TIPS ON ORGANIZATION

- Have professional slides and photographs taken of all your work. You will not regret the time and expense involved. It will come in handy later.

- Create a filing system for your photo references. You will not forget a good photo reference, only where you put it.

- Be ingenious. Brainstorm inventive ways to promote yourself. It will require meeting the public and the media, so gather your courage and begin.

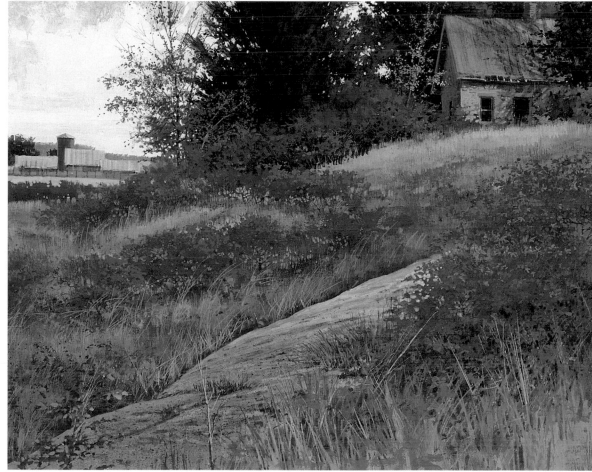

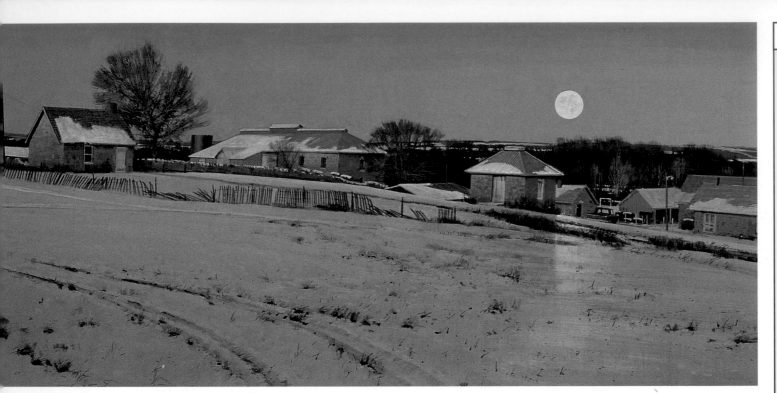

Smokehouse Moon
Acrylic on Gessoed Masonite
12" x 24" (30cm x 61cm)

→ Put as much of yourself as possible into each painting and paint with passion.

→ Some painters are able to produce a strong piece with little time and/or effort, while some painters work very hard and can't seem to get off the ground. The moral of this story? Hard work alone will not produce good art; you must also have a desire accompanied by passion.

→ Don't begrudge fellow artists their successes. This is hard, as artists and egos are born from the same womb. But you can strive to be your best.

→ Remember: You have the same amount of time each day as the Old Masters did.

→ Don't be discouraged by failure. A big success is often the result of many failures.

→ Force yourself to paint. Think like and athlete in training: no pain, no gain. If you have time to watch TV, practice painting instead.

→ There are more good artists than there are buyers. Competition is keen.

→ Remember. art critics are usually people who can't make a living with their own art, so don't be intimidated by them.

TIPS ON THE PROCESS

→ Begin working on the large shapes before worrying about detail.

→ To make an area glow, you must learn to paint the other areas of that painting in a subdued manner.

→ Drawing and sketching are important elements for a painter to master, but perhaps the single most vital focus is your subject. As you observe your subject matter, notice the size relationships, light and dark areas (values), colors and how they play off each other and textures.

→ Always look with a fresh eye! For example, while I consider myself a studio painter, painting outdoors brings new dimensions to my work. Painting en plein air offers many lessons about color, its relationship to other colors, the daylight (in all parts of the world) and atmospheric conditions. There are colors that cameras simply can't capture.

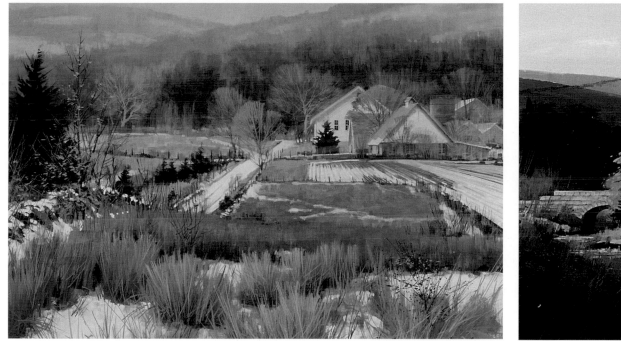

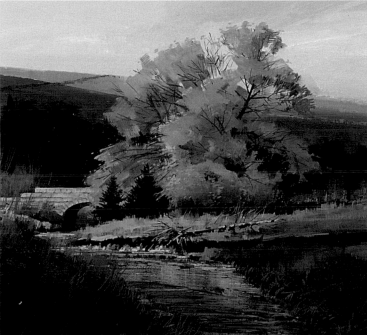

Ice-Elation
Acrylic on Gessoed Hardbord
12" x 16" (30cm x 41cm)

Gold at the End of the Rainbow Bridge
Acrylic on Gessoed Hardbord
12" x 12" (30cm x 30cm)

School Bus at Truchas
Acrylic on Gessoed Hardbord
12" x 24" (30cm x 61cm)

Buyer's Guide

Most of the materials used in this book can be purchased from your local art supply dealer. If you are unable to locate these materials, please contact the manufacturers below. Also listed are stores I use to purchase my materials.

Ampersand Art Supply

They will refer you to the dealer nearest you and send you information about their products.

Ampersand Art Supply
1500 E. Fourth Street
Austin, TX 78702
Phone: (512) 322-0278
Toll Free: (800) 822-1939
E-mail:
bords@ampersandart.com
Web site:
www.ampersandart.com

City Blue Print, Inc.

Buy directly from them.
Susie Colbert
City Blue Print, Inc.
1400 E. Waterman
Wichita, KS 67211
Phone: (316) 265-6224
Toll Free: (800) 535-PLAN
Fax: (316) 265-2459
Web site: www.cityblue.com

Golden Artist Colors, Inc.

They will send you the latest information about their products and locate the dealer nearest to you. Call for free, hand-painted color charts.

Golden Artist Colors, Inc.
188 Bell Road
New Berlin, NY 13411
Phone: (607) 847-6154
Toll Free: (800) 959-6543
FAX: (607) 847-9868
E-mail:
orderinfo@goldenpaints.com
Web site:
www.goldenpaints.com

H.R. Meininger Company

Buy directly from them, everything is in stock.

Stacey Plomondon
H.R. Meininger Company
499 Broadway
Denver, CO 80203
Phone: (303) 698-3828
Ext. 106
Toll Free: (800) 950-ARTS
Fax: (303) 871-8676
Web site:
www.meininger.com

Jerry's Artarama

Buy directly from them, everything is in stock. Call for free catalog.

Jerry's Artarama
P.O. Box 58638J
3060 Wake Forest Road
Raleigh, NC 27658
Phone: (919) 876-6610
Toll Free: (800) 827-8478
Fax: (919) 873-9565
E-mail: uartist@aol.com
Web site:
www.jerryscatalog.com

Underestimating the Challenge
Acrylic on Crescent Illustration board no. 1
15" x 24" (38cm x 61cm)

Acknowledgements

All the names listed here are in alphabetical order except for my wife's and I must insist that she be named first. Terry Greer: There is no way this book could have been done without her help and dedication. She is the business and brains end of me. Without her I would not be a whole person. She also has the good clean hands that are used throughout the book.

Scott and Judy Addison: Judy is a childhood friend and we talk about old times. Scott loves a good auction.

Sam Bailey: A brother-in-law who is good to me but worries about his sister because he is still trying to figure out what I do for a living.

Doran Barham: A truly good person and a great artist. He is missed.

Linda Branch: Linda does a great job of promoting the artisans of Kansas in her gallery, The Courtyard. She's a true patron of Swedish traditions and Lindsborg is lucky to have her.

Susie Colbert: A great help with art supplies at City Blue Print, Inc. and a good friend.

Jeff and Janet Craghead: My favorite curmudgeon and his pretty wife. Likes to refer to acrylic art as plastic paintings.

Marilyn Daiker: Always available at North Light Books to answer any questions with a smile on her face that you can see through the telephone. She eats blueberry pancakes and goes hiking with bears.

Wilbur Elsea: A friend who has been a guiding light and mentor but hasn't heard a word I've said. He's a great storyteller, watercolorist, fisherman (but he wants me to find the fish first and then call) and all 'round pal.

ETS Graphics/Velocity: Danny, Dennis, Javin, Kerry and Nadine help me out when I'm faced with impossible deadlines. They do superb work and are nice to work with.

Philip Frangenberg: Philip introduced me to the fine people and products at Golden. (He is also a fishing pal).

Barbara Golden: Part of a successful family company with a great product line. She has been lots of help with this book with answers and advice on Golden products.

David and Tena Greer: My favorite cousin (a great artist himself) and his wife. David's nervous energy could generate enough electricity to light a city. Tena is his calming force.

David Harlan: Showed me the importance of painting outdoors.

B. J. Kingdon, Ed Law, Keith Parker, and Keith Rhoades: Four gentlemen who helped me in the very beginning as an architectural illustrator. Their guidance was my "school."

Chuck and Jackie Loomis: I sold my first painting to my sister Jackie. I took the painting back. Kept the money. She never complained.

Jack and Carter Luerding: Longtime friends who love fine art.

Jamie Markle: My in-house editor at North Light. A Yankee who tried to paint with an Indian Paint Brush.

Mike Michaelis: A good friend of the Kansas Watercolor Society. Many benefit (including me) from his patronage of the arts.

Jack and Georgia Olsen: They have a very distinguished gallery in Kansas City, Missouri, the American Legacy Gallery.

Steve Onkin: Those who know him are glad they do. He has a love for art and donates his spare time to good causes.

Ed Pointer: He taught me which end of the camera should be aimed at the subject (that's why his name is *pointer*). Ed has been tireless in his devotion and dedication. He's also a fellow artist and best friend who laughs at me and with me.

Andrea Pramuk: Always available with information on Ampersand products.

Jim Ray: Had compassion for an old baseball doofus.

Bob and Lucille Riegle: They own the finest gallery in Wichita, Kansas, the Wichita Gallery of Fine Art. I'm pleased to have been represented by them for twenty-three years.

Marlin Rotach: A friend and fine watercolorist who is always a threat as the one to take home the "big award."

Dionne Russel: One of Santa Fe's finest. Dionne has a lot of business savvy and knows good art. She can usually be found at the Santa Fe Opera.

Linda Shockley: A writer friend who helped me outline this book and wrote my biography. She unscrambles my words and makes my sentences work. She has too much fun in her spare time.

Pat and Vaughn Sink: Good friends who give me lots of encouragement. They have great taste in art. Can you imagine why I would say that?

Karen Spector: Karen helped write this book. What would I have done without her? However, she needs to write another book about her life and family—there never seems to be a dull moment!

Cathy Bolon Stephenson: A very talented writer, piano player, singer, songwriter and actress who can make you glad you're part of the audience. She also knows a lot about fine art and played a huge role in helping to launch my fine art career.

Mike Townsend: Works for Golden, has been a great technical advisor and knows his business well.

Ernie Ulmer: My original art hero; the best architectural delineator ever. I tried to paint like him.

UPS and FedEx: They made lots of overnight deliveries so I could meet my deadlines.

Al Wadle: Al has helped guide my fine art career and has the finest gallery in Santa Fe, the Wadle Galleries, Limited. He is one of Santa Fe's Living Treasures.

Doug and Carla Walker: Longtime friends who can catch big fish (and then have me clean them—so you know I really like these two). If Doug and Carla read this, please call me.

Ray Walton: I learned more about business from Ray in one day than through all my college years put together. You should visit his Flint Oak Ranch.

Rachel Wolf: A big encouragement and help to me in getting this book off the ground.

If your name was left out I am truly sorry. But not all is lost. I've furnished a space below for you to fill out:

Your name here:

_____.

Index

Explore Acrylic Painting
With North Light Books!

These books and other fine North Light titles are available from your local art & craft retailer, bookstore, on-line supplier or by calling 1-800-221-5831.

Learn the easy way to create a sense of depth in your paintings! Phil Metzger gives you clear-cut guidelines in everyday terms with a little humor tossed in along the way. He understands how you work and he knows that the last thing you need is a lot of rigid rules to tie you down. You'll learn techniques of perspective that will help your creativity, not hinder it.

0-89134-446-2, paperback, 136 pages, #30386-K

Learn how to properly execute basic acrylic painting techniques—stippling, blending, glazing, masking or wet-in-wet—and get great results every time. Jacqueline Penney provides five complete, step-by-step demonstrations that show you how, including a flower-covered mountainside, sand dunes and sailboats, a forest of spruce trees and ferns, a tranquil island hideaway and a mist-shrouded ocean.

1-58180-042-8, hardcover, 128 pages, #31896-K

Here's the reference you've been waiting for! Inside you'll find 28 step-by-step demonstrations that showcase the methods that can help you master the many faces of acrylic painting—from the look of highly controlled transparent watercolor to abstract expressionism, and everything in between. Seven respected painters make each new technique easy to learn, illustrating just how versatile acrylics can be.

1-58180-175-0, paperback, 128 pages, #31935-K

This book is for every painter who has ever wasted hours searching through books and magazines for good reference photos only to find them out of focus, poorly lit or lacking important details. Artist Gary Greene has compiled over 400 gorgeous reference photos of landscapes, all taken with the special needs of the artist in mind. Six demonstrations by a variety of artists show you how to use these reference photos to create gorgeous landscape paintings!

0-89134-998-7, hardcover, 144 pages, #31670-K

More than one thousand art-related definitions and descriptions are detailed here for your benefit. Including every term, technique and material used by the practicing artist, this unique reference is packed with photographs, paintings, mini-demos, black & white diagrams and drawings for comprehensive explanation. You'll also find sidebars about specific entries and charts for a wealth of inter-related information in one convenient listing.

1-58180-023-1, paperback, 486 pages, #31677-K